MINICELEBRITY BIBLE

TECTUM
PUBLISHERS

MINI CELEBRI

TY BIBLE

© 2011 Tectum Publishers
Godefriduskaai 22
2000 Antwerp
Belgium
info@tectum.be
+ 32 3 226 66 73
www.tectum.be

ISBN: 978-90-79761-83-8
WD: 2011/9021/20
(130)

EDITOR & TEXTS: Paz Diman
PHOTOGRAPHY: © Cordon Press
DESIGN : Gunter Segers

PRINTED IN CHINA

PREFACE PRÉFACE INLEIDING

Of all the important figures who have formed a part of our lives, who are the ones that live on in our memory? Who have left an almost indelible mark in our memories and even on the way we are? What names do we hold dear, as if they were little treasures from the past?

Just like the lists of celebrities compiled by the press, this work offers you a selection of the greater and lesser myths of contemporary culture. Actors, film directors, artists, sportsmen and women, scientists, business leaders, and cult heroes are brought together in these 384 pages.

All the celebrities that were chosen tell us the story of our time. For their immense contribution to science, for being an icon of tremendous beauty, for having revolutionized the art world, for having beaten impossible records and even for being the holder of an indisputable attribute, Luc Montagnier, Brigitte Bardot, Salvador Dalí, Carl Lewis and Mister T are some of the celebrities appearing in this book. In short, the last sixty years condensed in these 250 photographs. Now is the time to relive them.

Parmi toutes les personnalités qui ont fait partie de nos vies, lesquelles subsistent dans notre mémoire ? Lesquelles ont laissé une empreinte presque indélébile dans nos souvenirs et même dans notre façon d'être ? Quels noms conservons-nous comme de petits trésors du passé ?

À l'instar des listes de stars élaborées par les médias, cet ouvrage vous propose un éventail des petits et des grands mythes de la culture contemporaine. Acteurs, réalisateurs, artistes, sportifs, scientifiques, hommes d'affaires et héros de la culture populaire se donnent rendez-vous au fil de ces 384 pages.

Toutes les personnalités choisies nous racontent l'histoire de notre époque. Parce qu'il a énormément apporté à la science, parce qu'elle est l'icône la plus explosive de la beauté, parce qu'il a révolutionné le monde de l'art, parce qu'ils ont relevé des défis impossibles et aussi parce que tous possèdent une singularité indiscutable, Luc Montagnier, Brigitte Bardot, Salvador Dalí, Carl Lewis et Mister T sont quelques-unes des personnalités qui figurent dans ce livre. En définitive, ce sont ces soixante dernières années résumées en 250 photographies. Et c'est le moment de s'y plonger !

Welke personages die deel uitgemaakt hebben van ons leven zullen in ons geheugen gegrift blijven? Wie hebben een bijna onuitwisbaar spoor in onze herinneringen en zelfs in onze manier van zijn achtergelaten? Welke namen bewaren we als kleine schatten uit het verleden?

Wij bieden u in dit werk, in de vorm van lijsten met beroemdheden die door de media worden opgesteld, een selectie van kleine en grote mythen van de hedendaagse cultuur. Acteurs, filmregisseurs, kunstenaars, sporters, wetenschappers, ondernemers en helden van de volkscultuur worden in deze 384 bladzijden bijeengebracht.

Alle gekozen personages vertellen de geschiedenis van onze tijd. Vanwege hun immense bijdrage aan de wetenschap, omdat ze een icoon van ongeëvenaarde schoonheid waren, een revolutie teweeggebracht hebben in de wereld van de kunst, onmogelijke records hebben verbeterd of de bezitters waren van een onweerlegbare bijzondere eigenschap. Luc Montagnier, Brigitte Bardot, Salvador Dalí, Carl Lewis en Mister T zijn een aantal van de persoonlijkheden die in dit boek voorkomen. Kortom, de laatste zestig jaar samengevat in deze 250 foto's. Sla de bladzijde om en neem een kijkje in de wereld van deze beroemdheden.

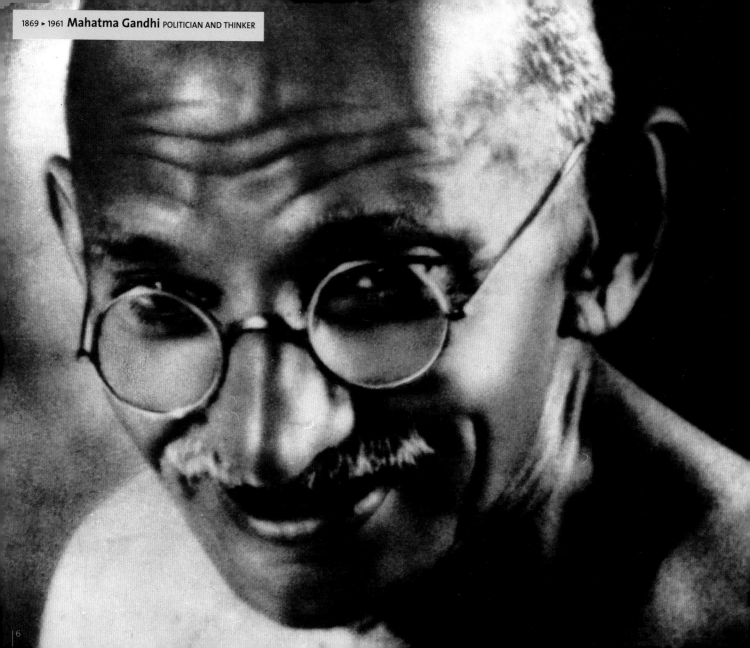

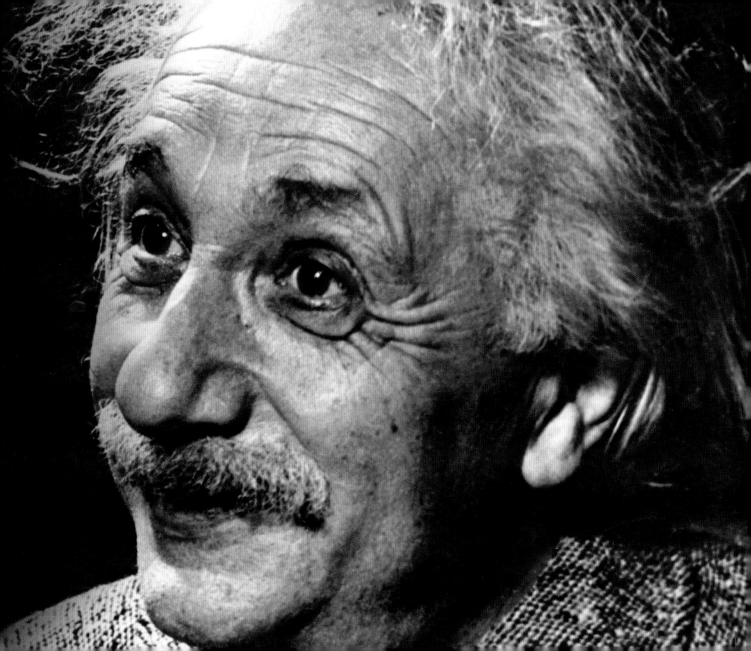

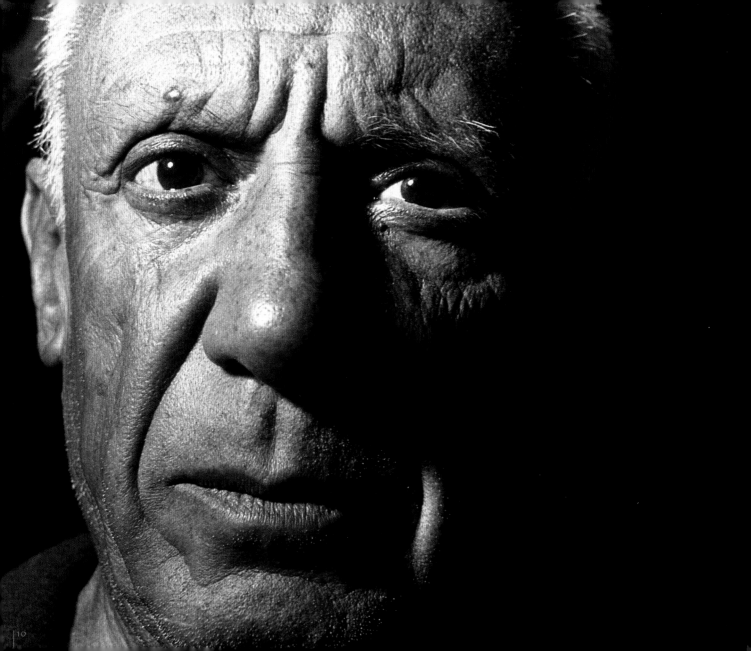

1887 ▸ 1968 **Marcel Duchamp** ARTIST

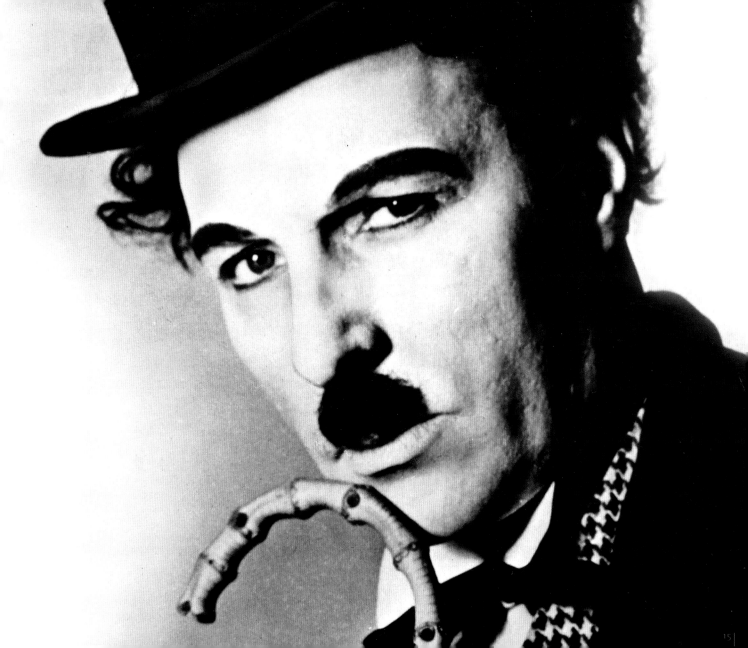

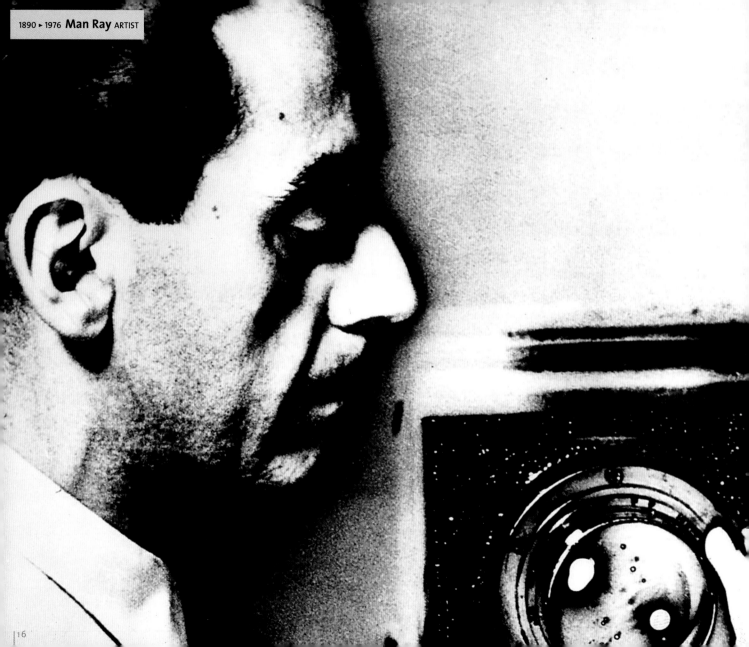

1892 ► 1973 **J. R. R. Tolkien** WRITER

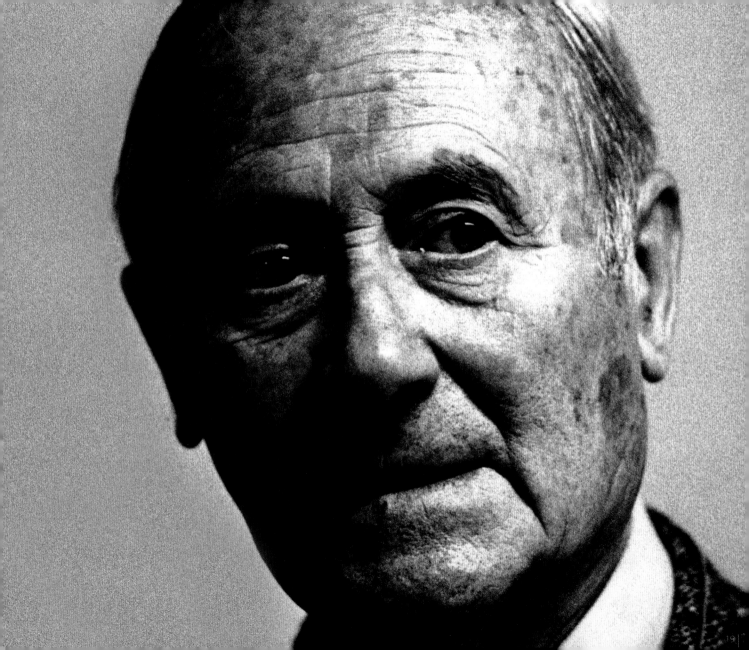

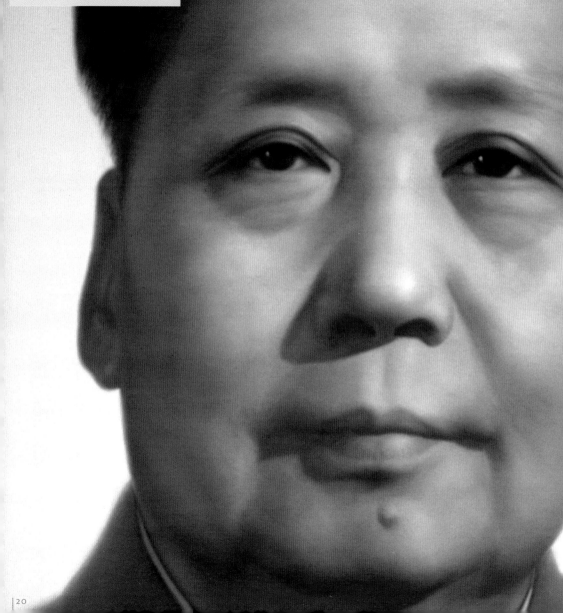

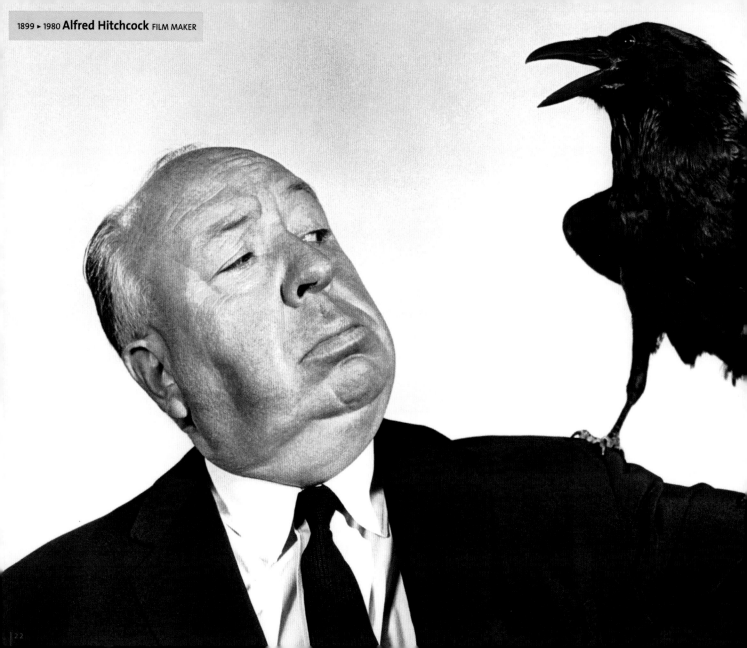

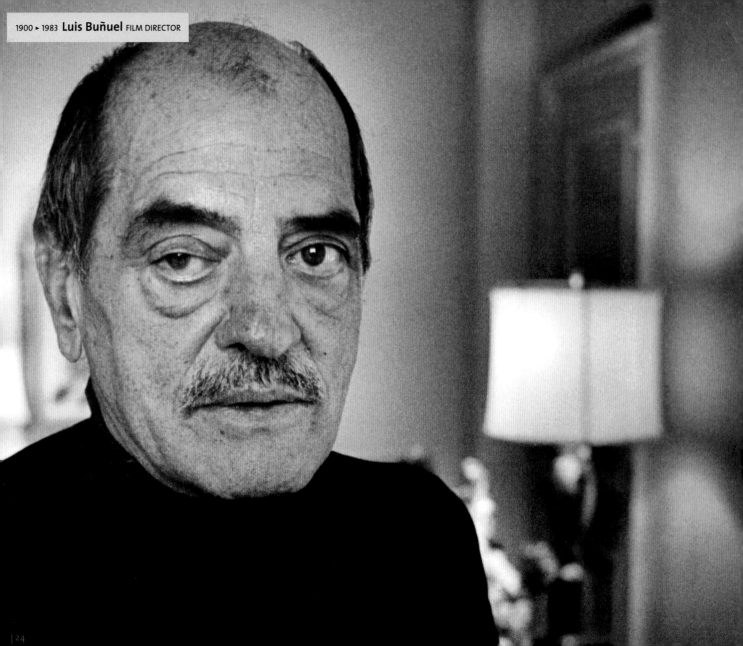

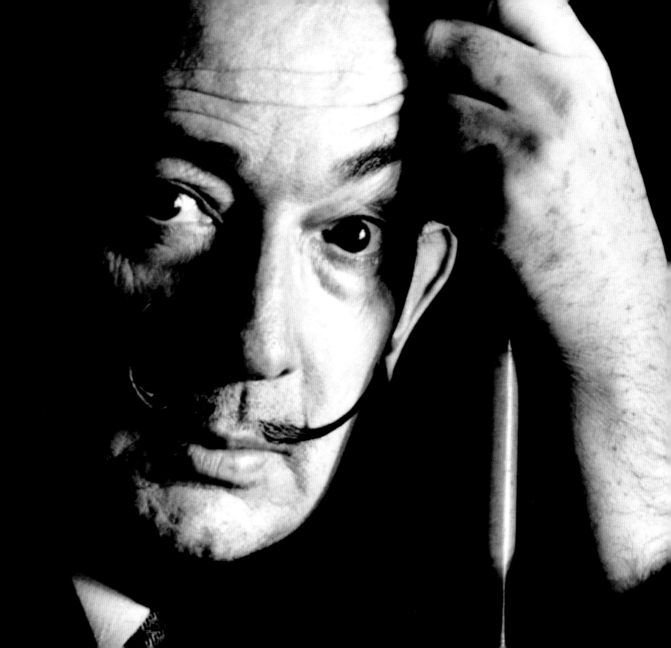

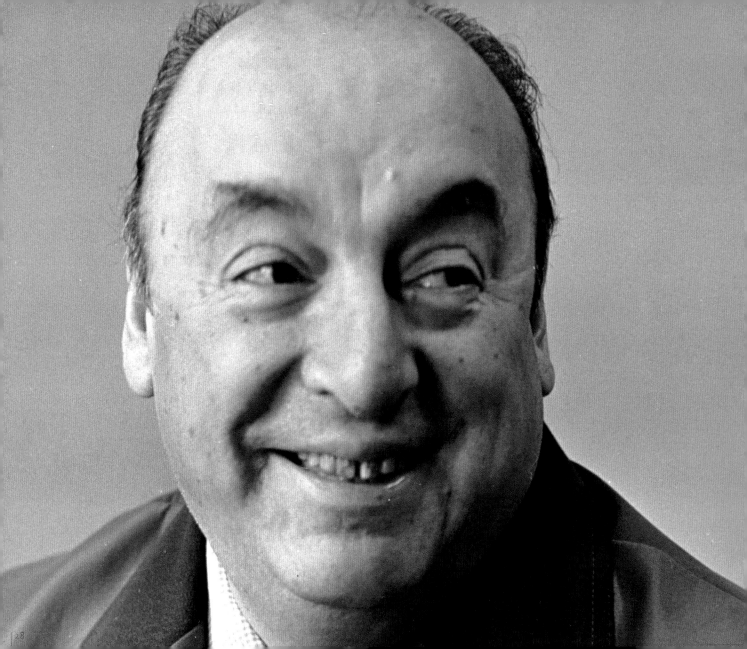

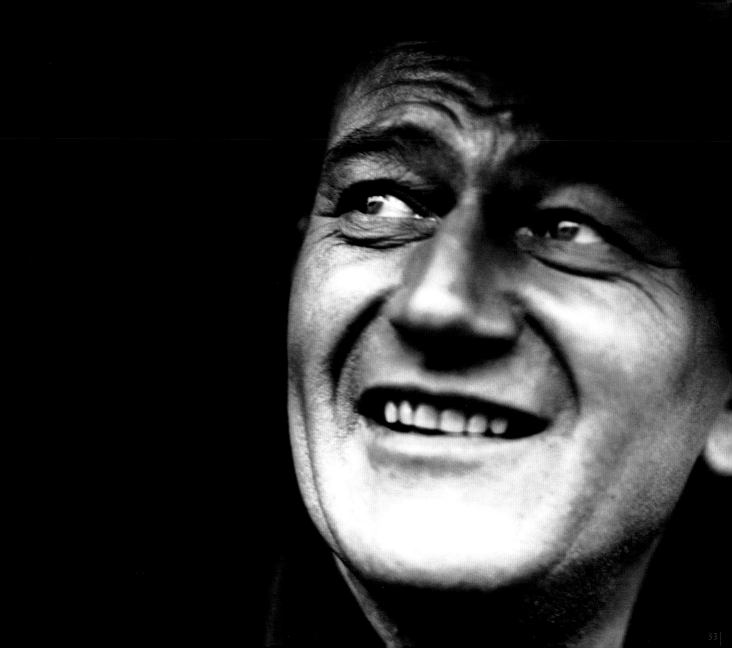

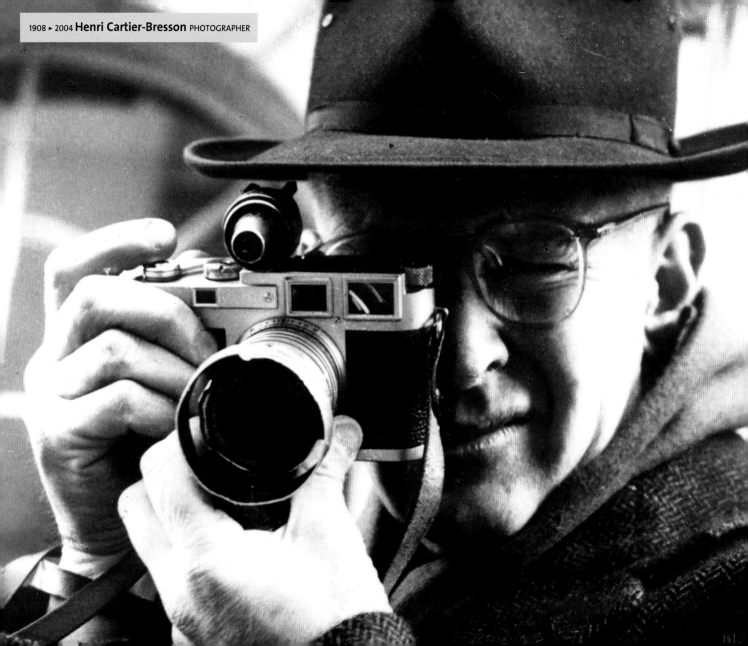

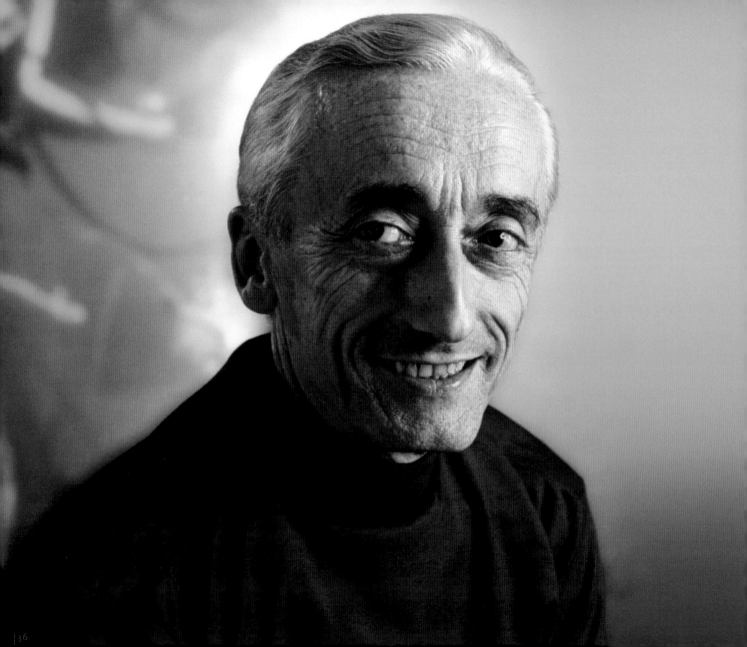

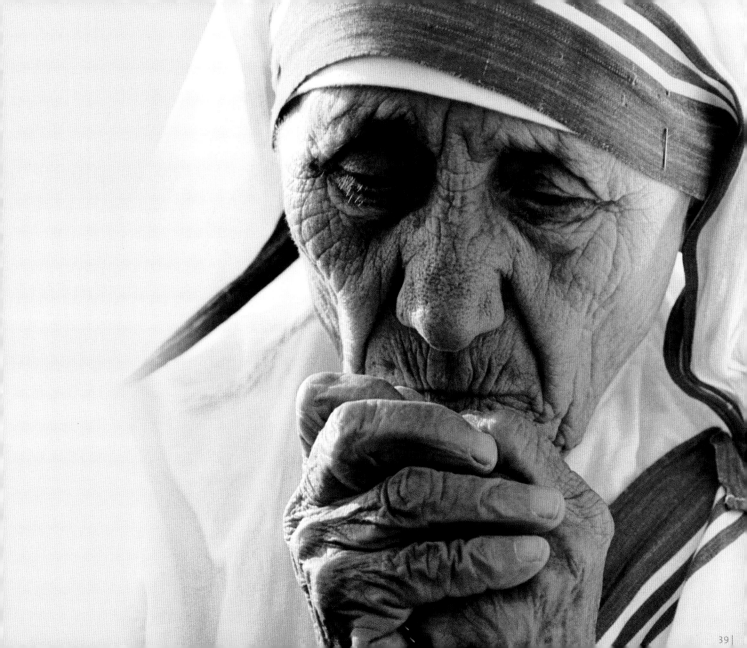

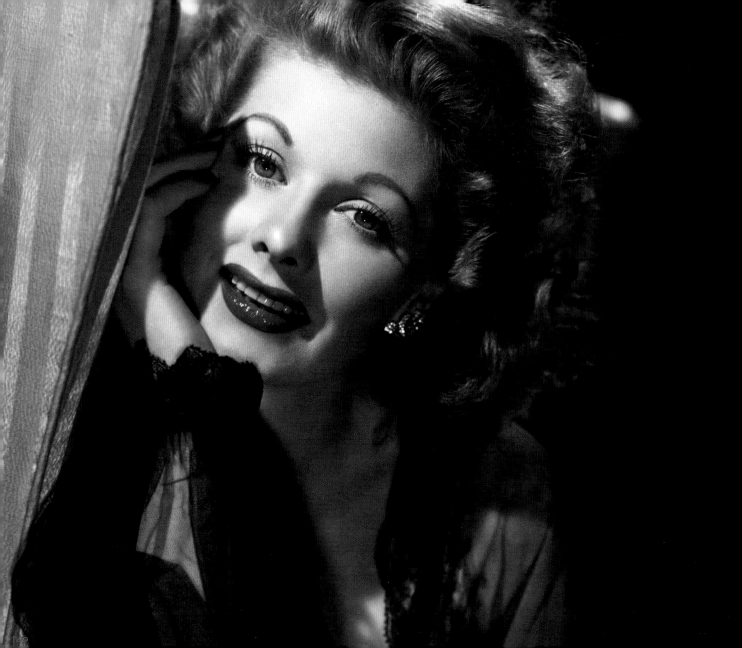

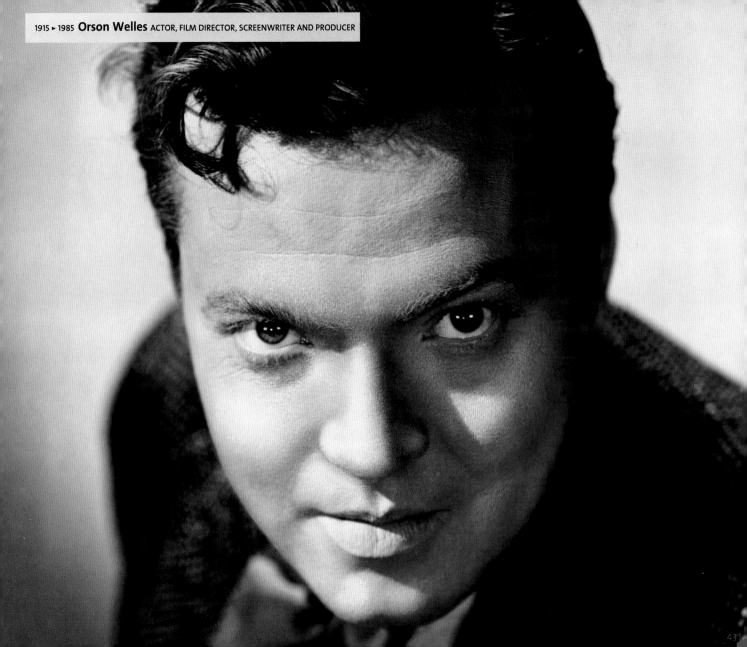

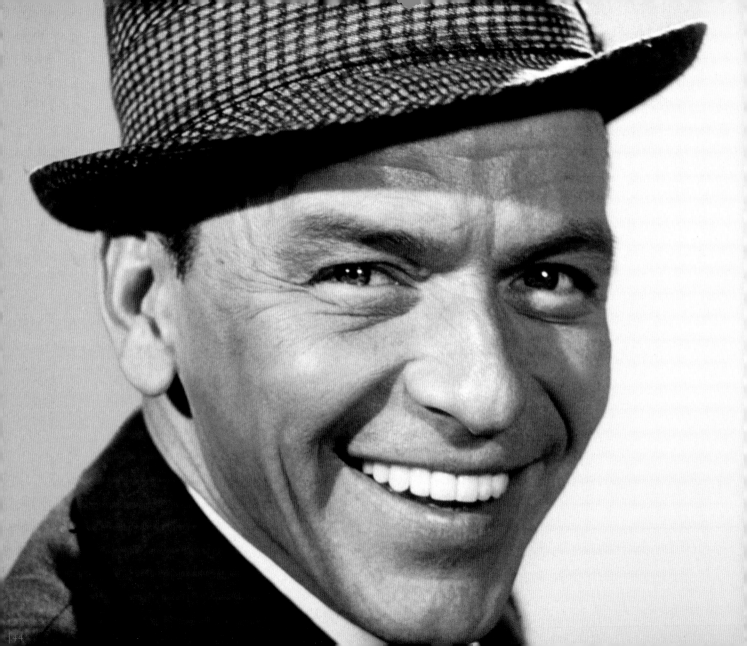

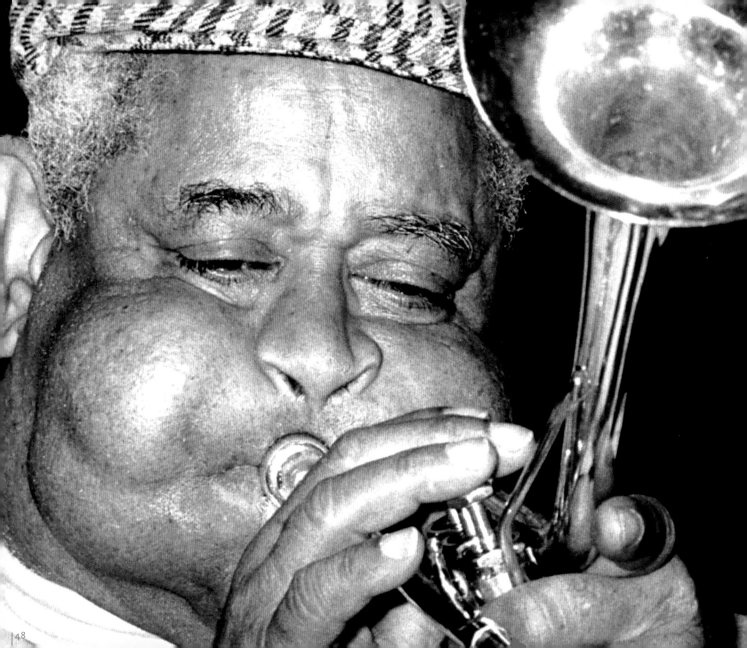

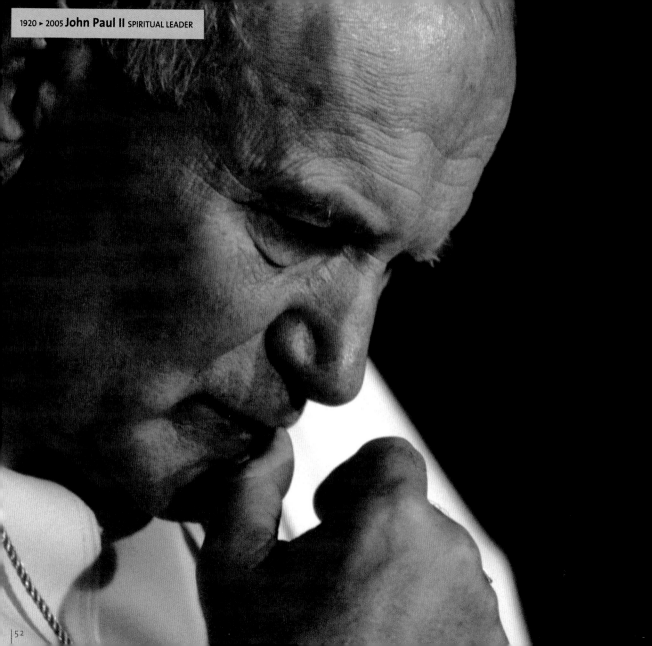

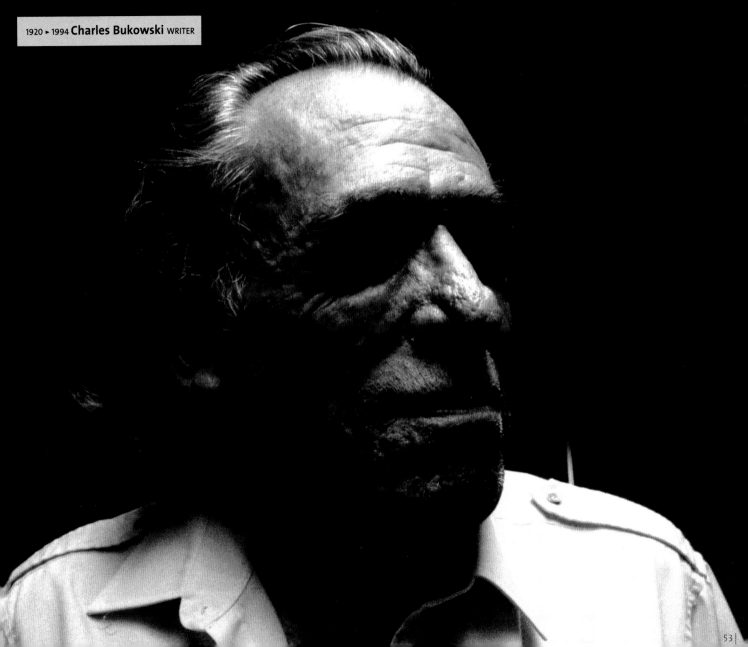

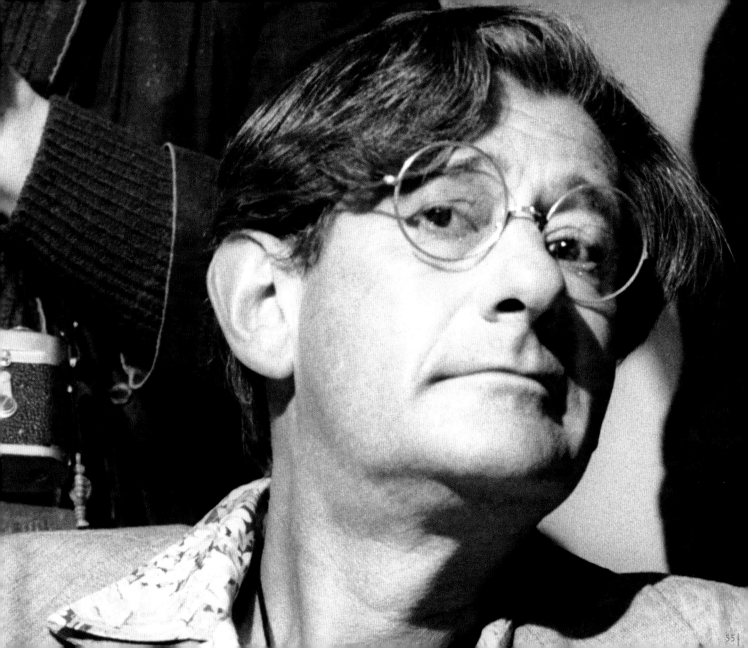

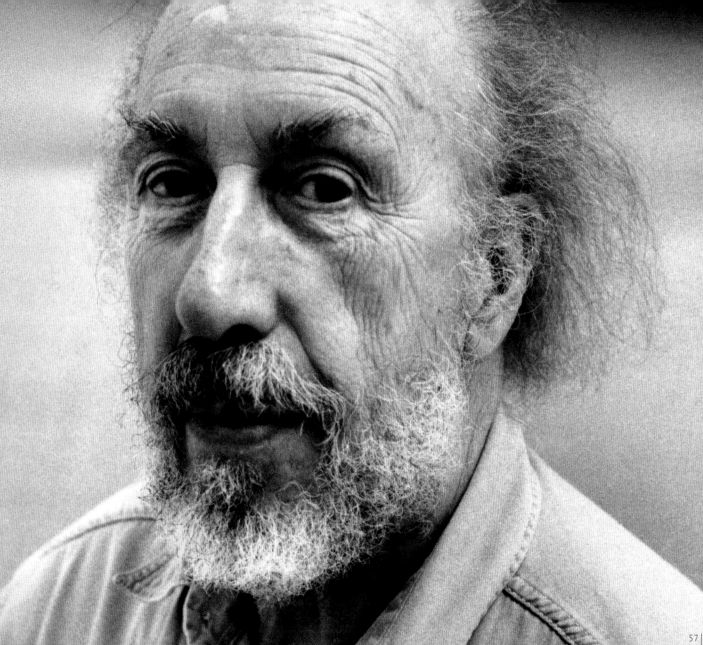

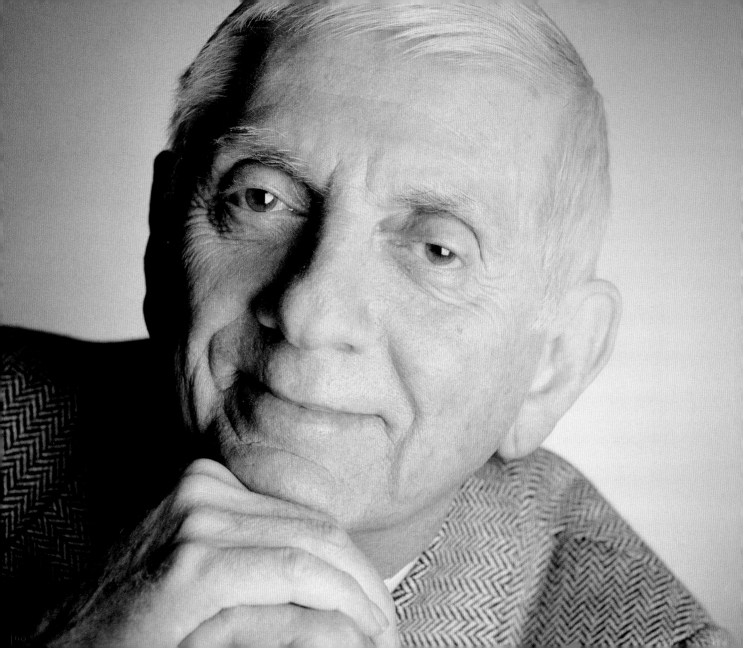

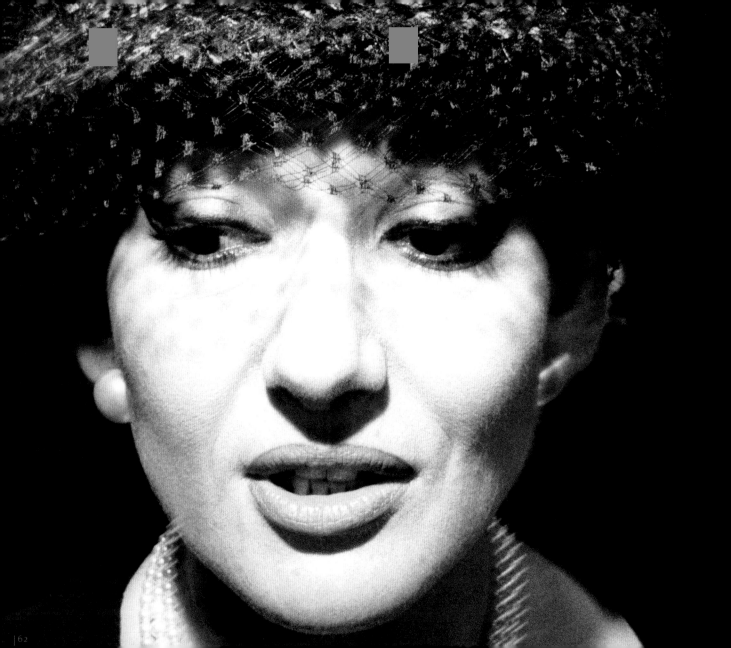

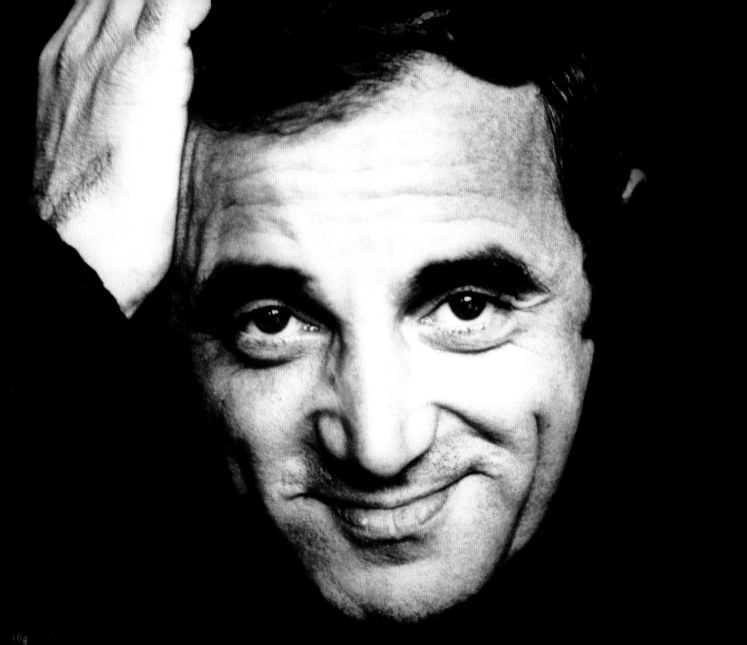

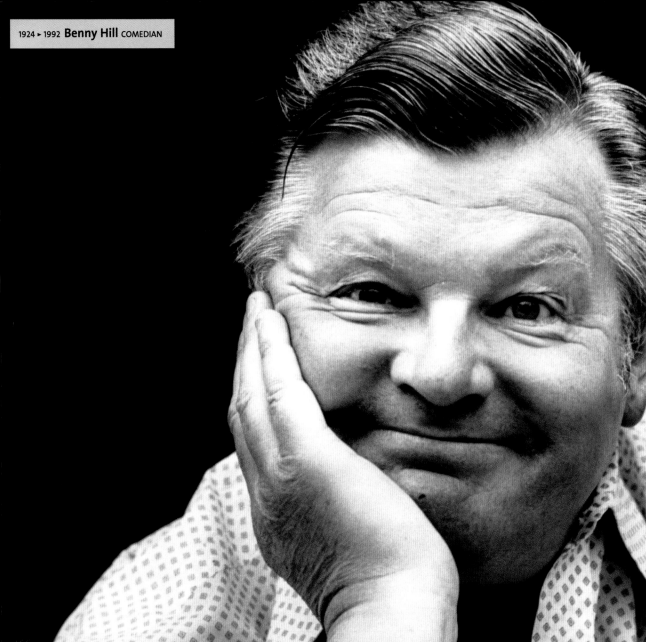

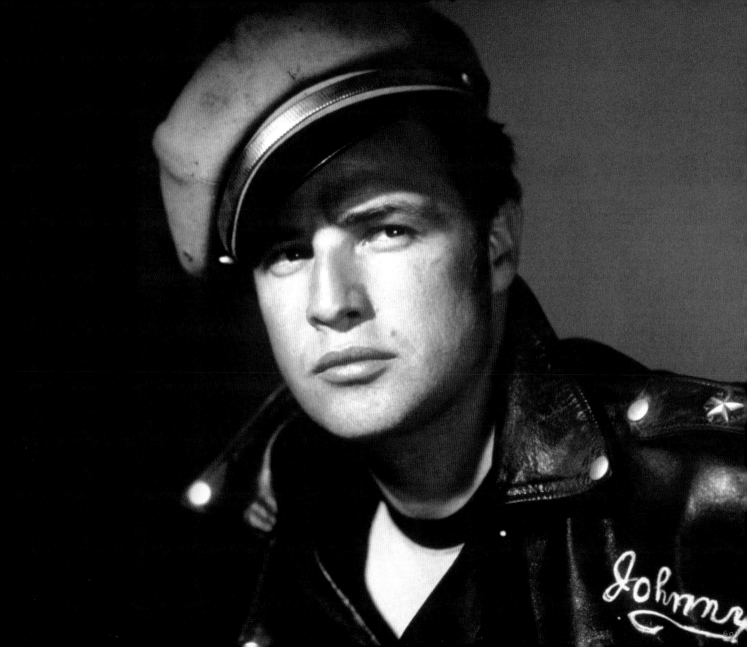

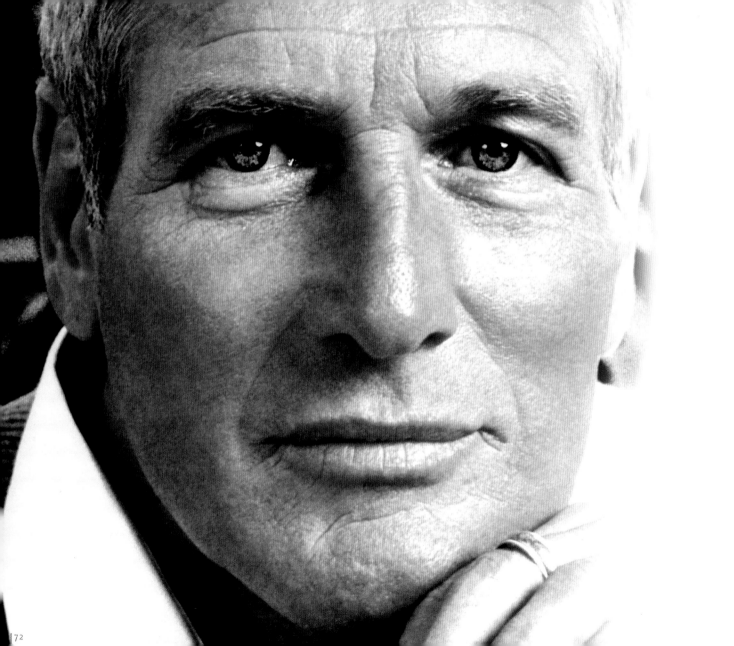

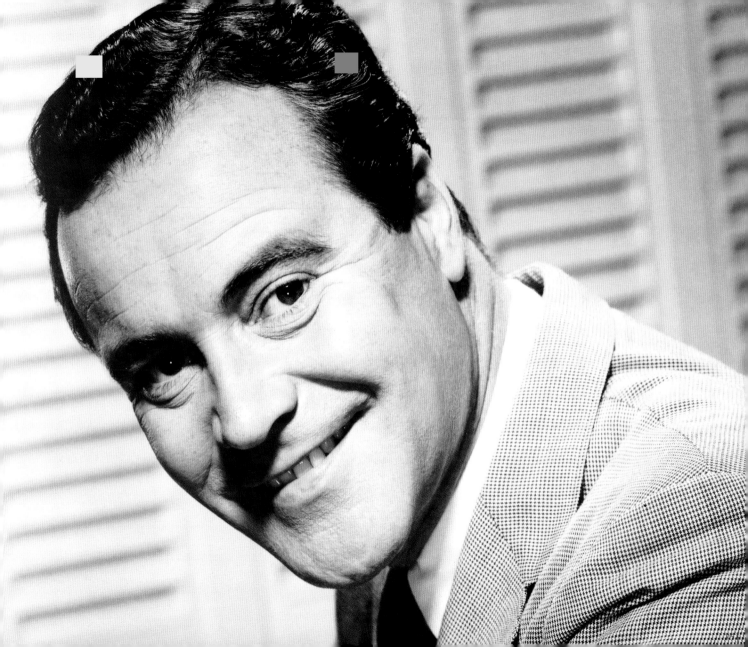

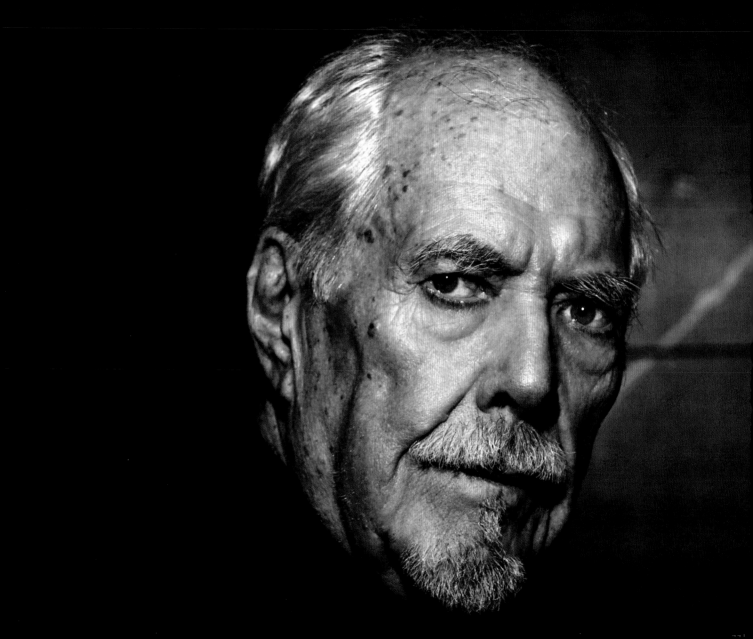

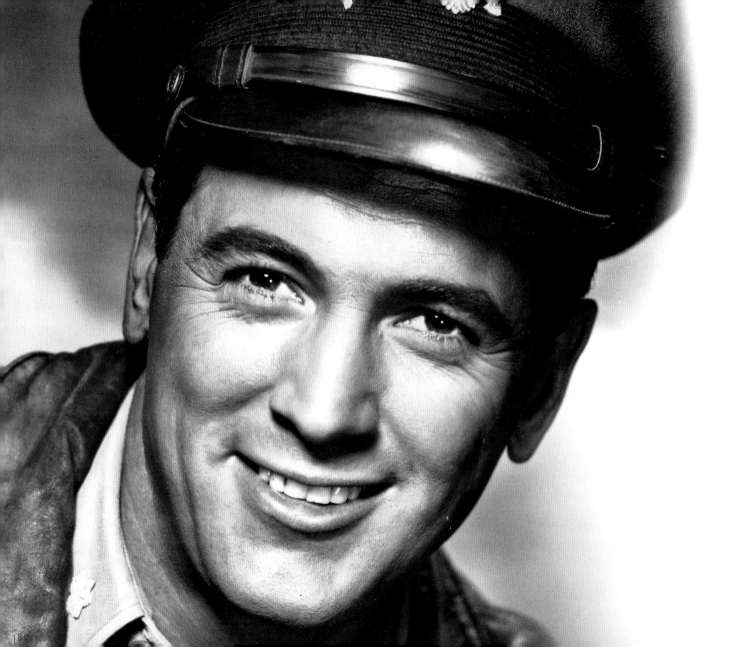

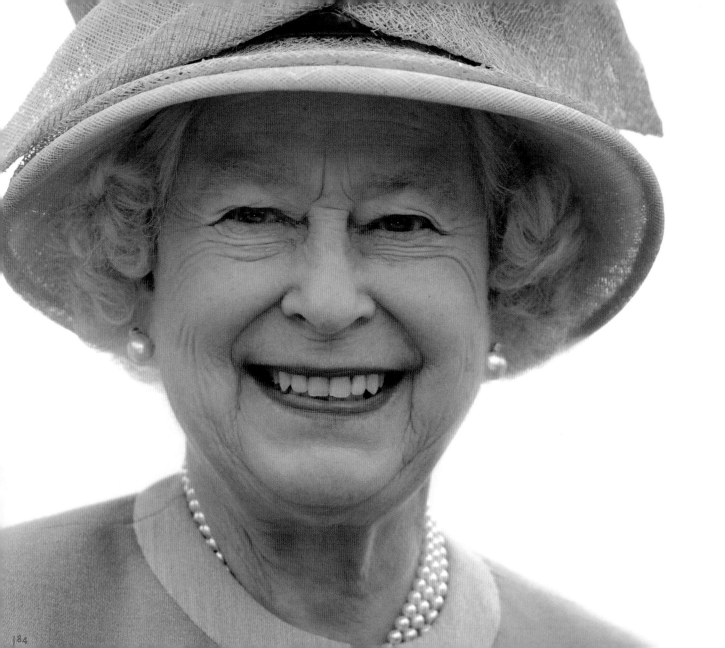

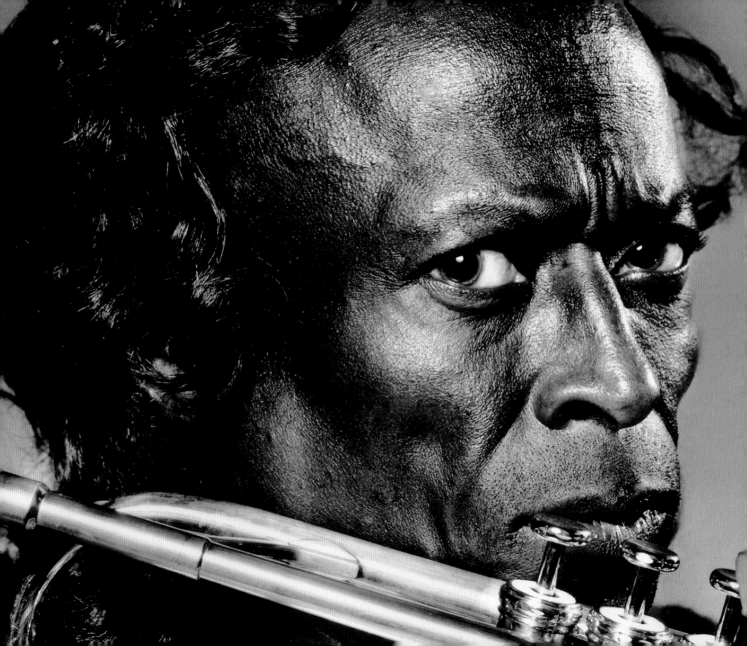

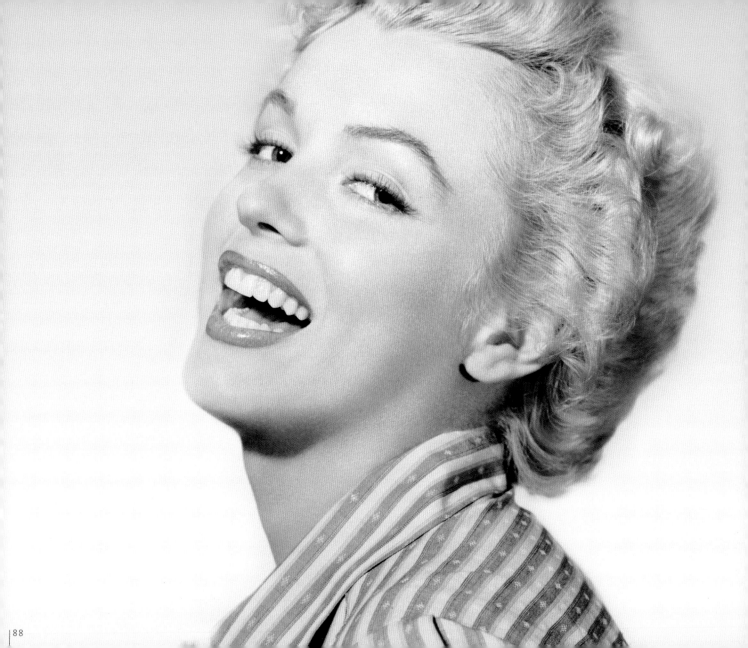

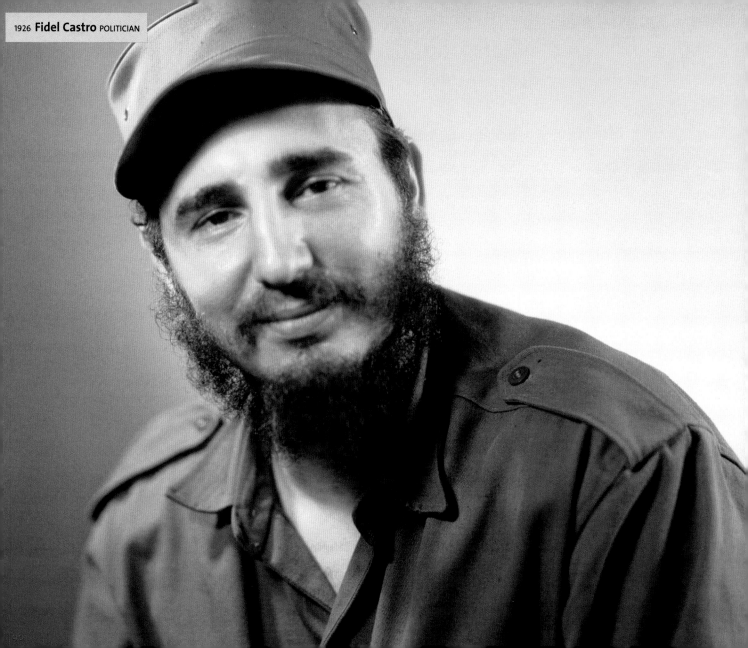

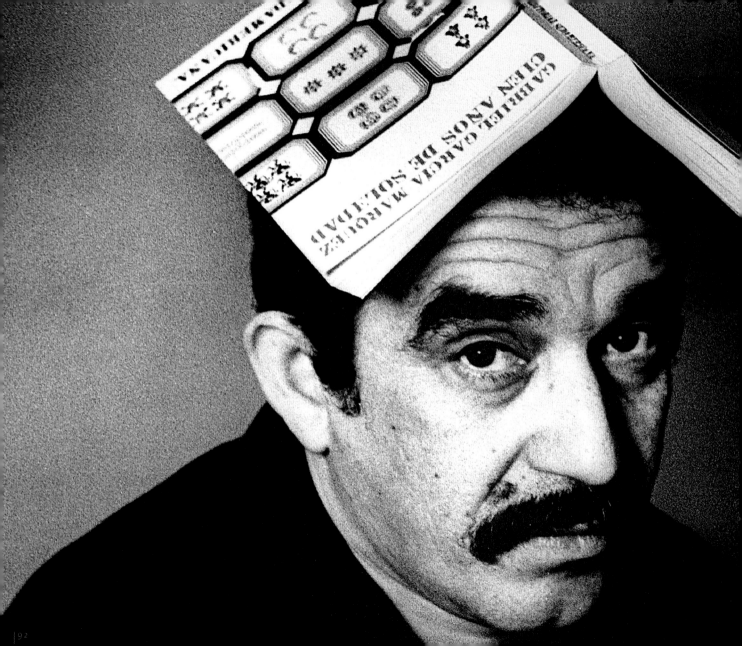

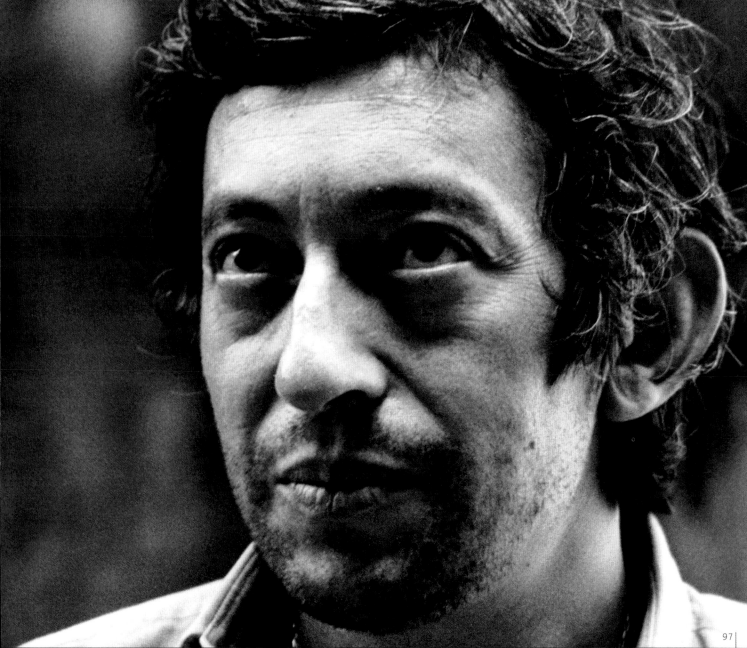

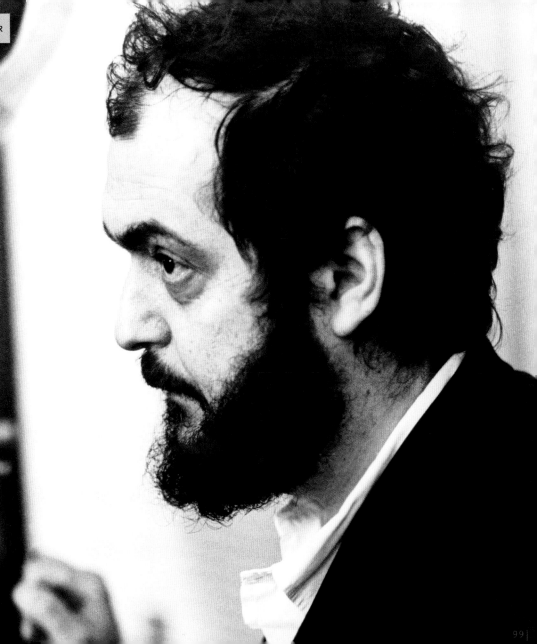

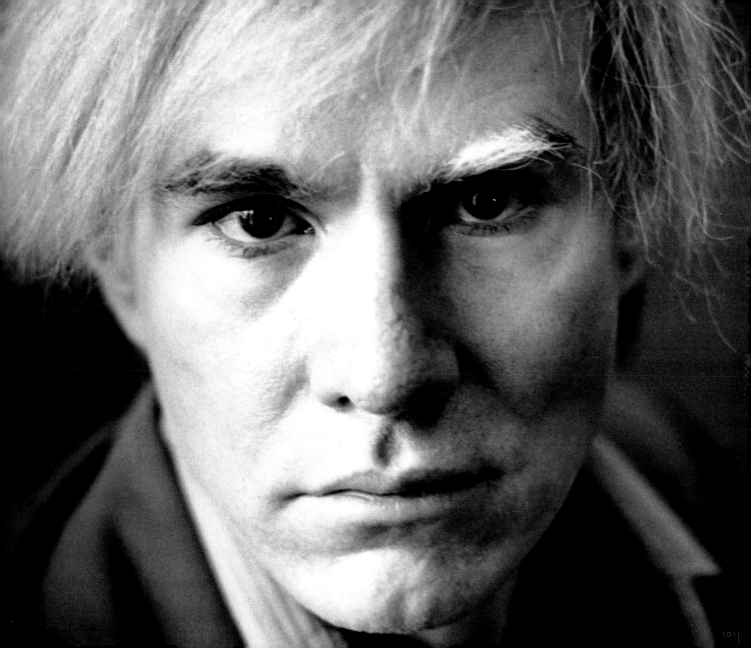

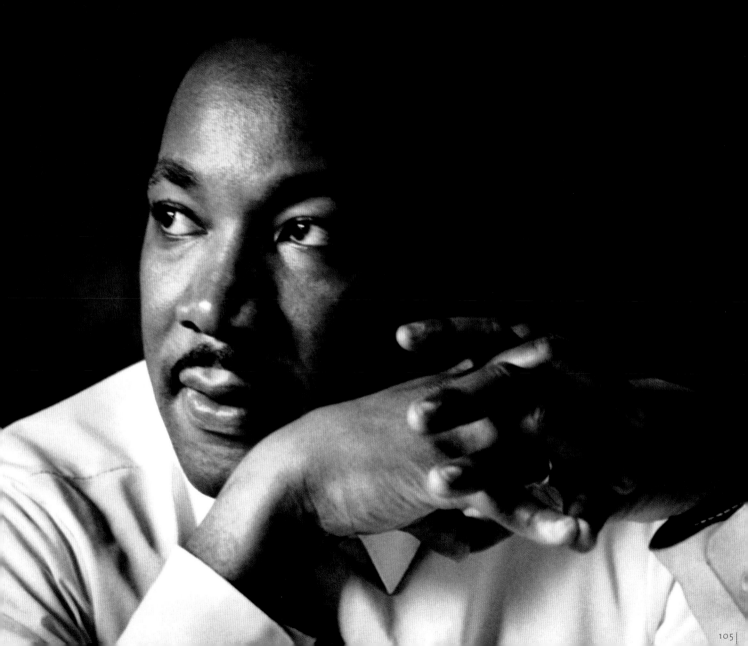

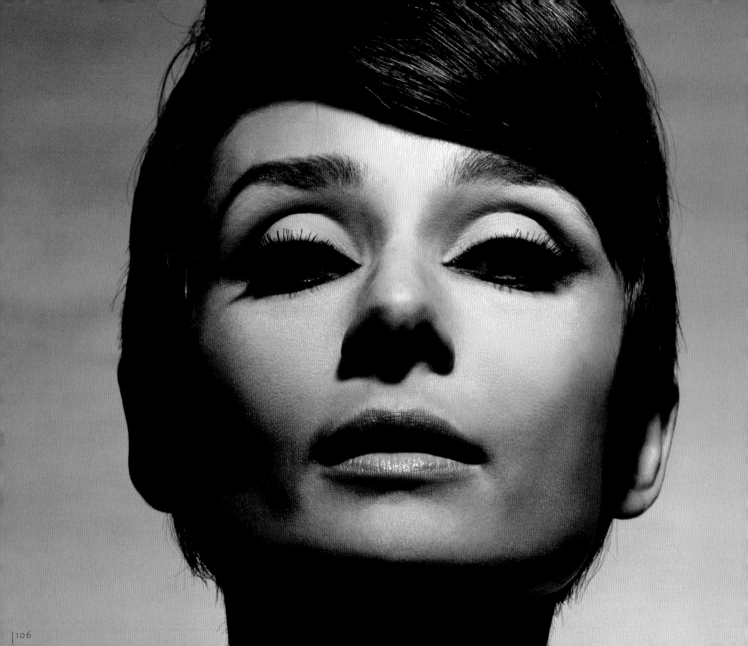

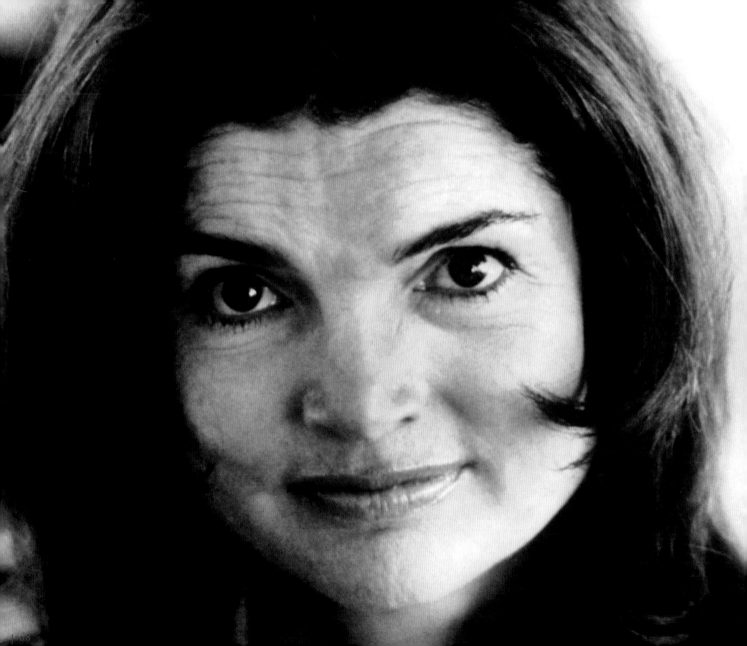

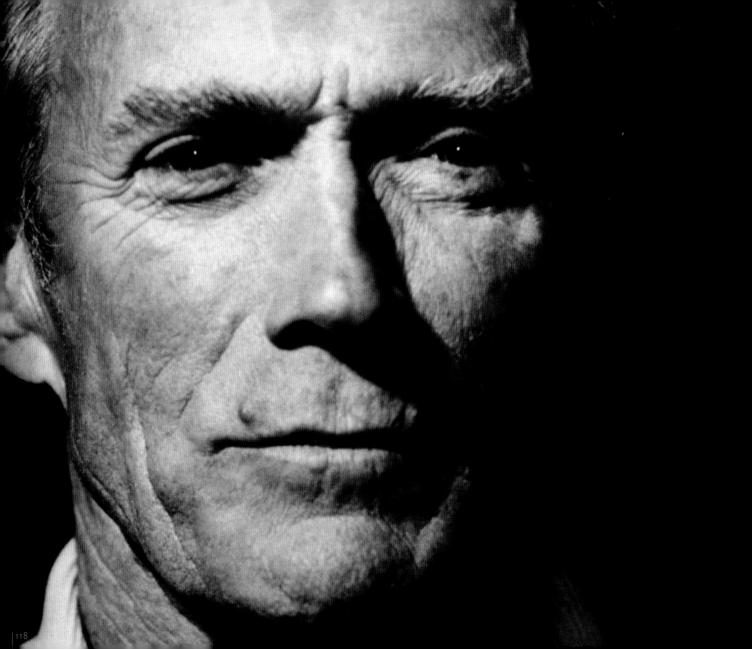

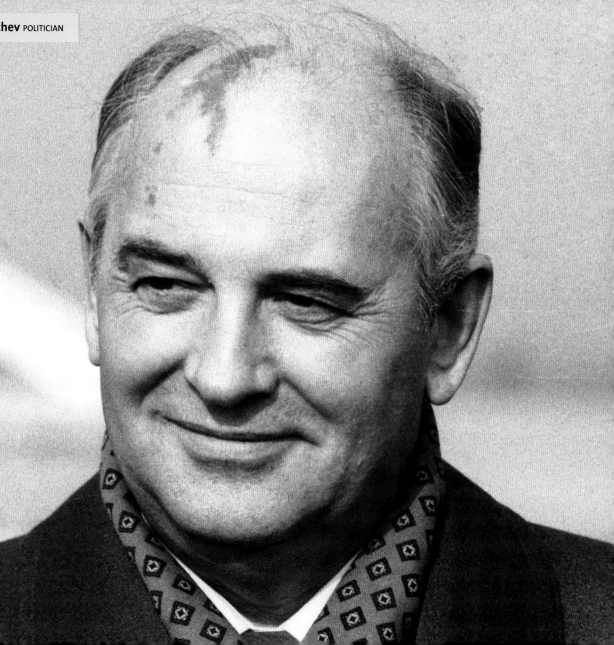

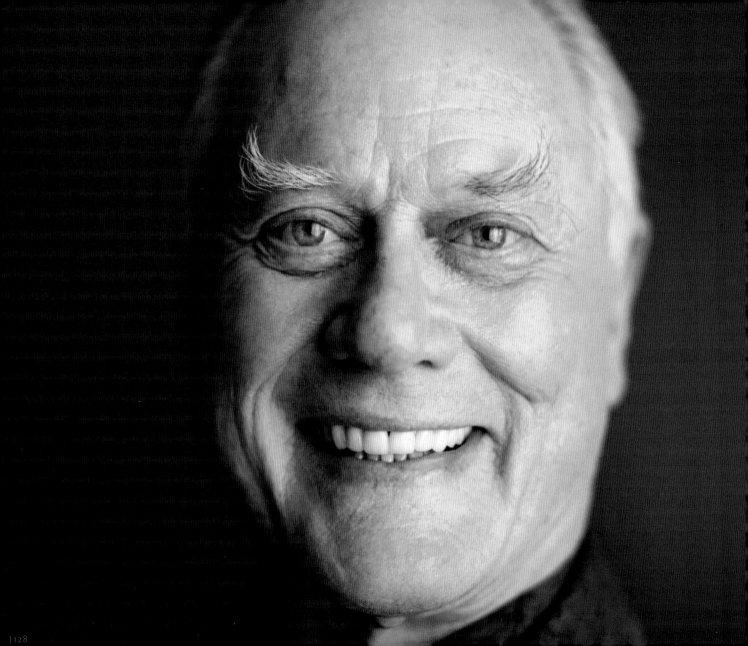

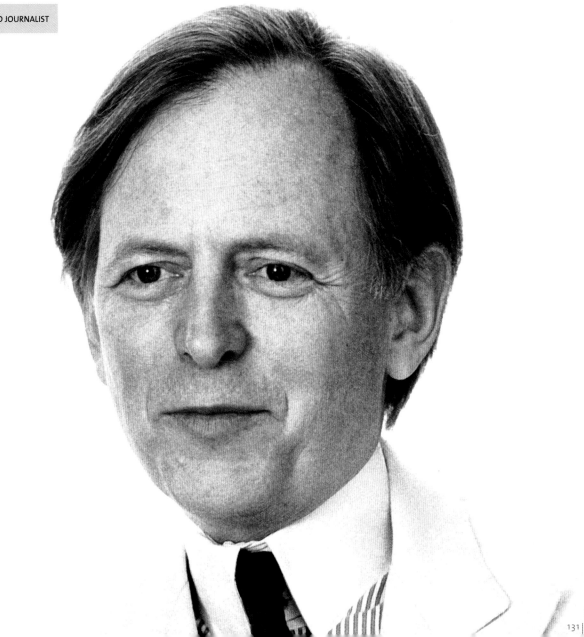

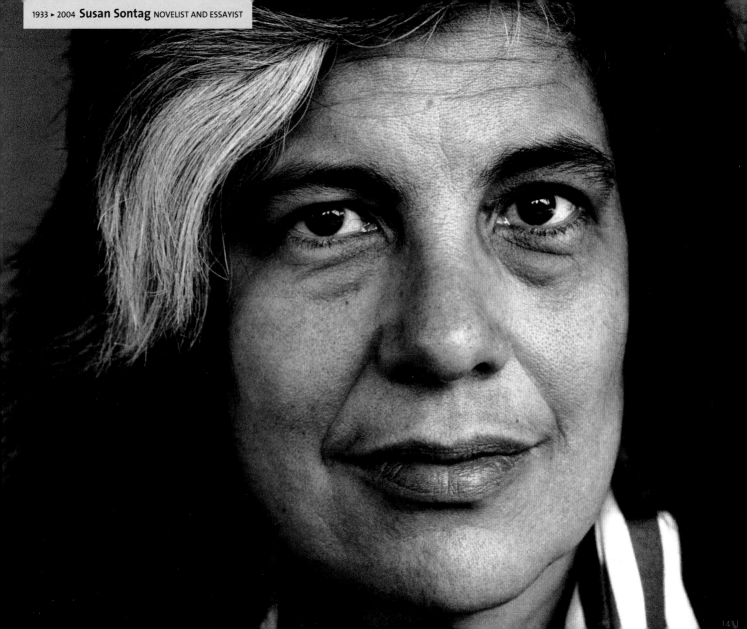

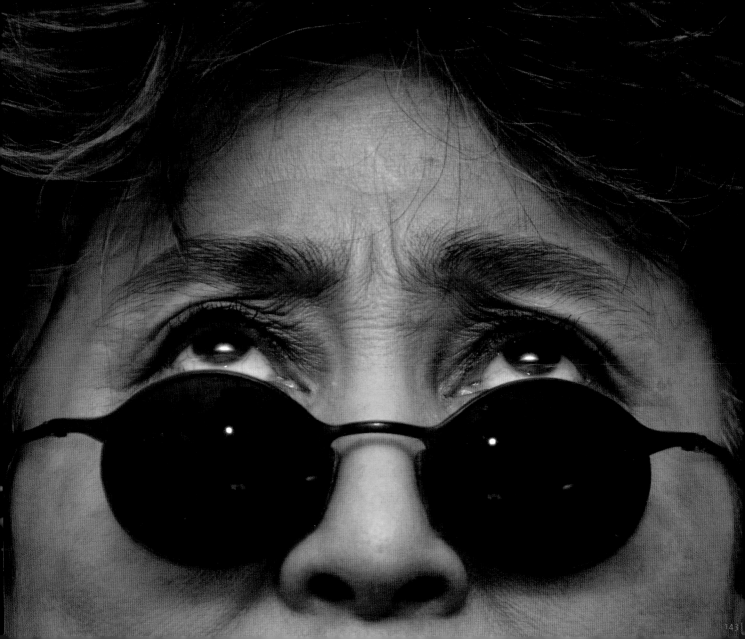

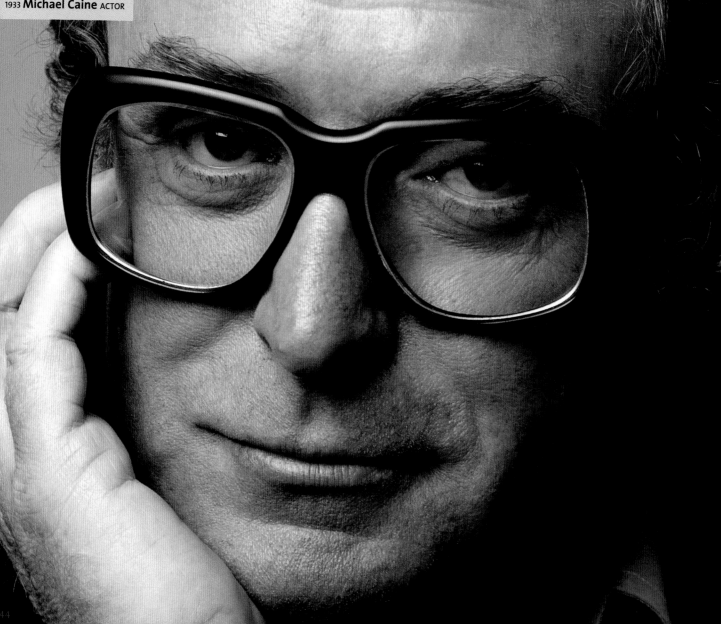

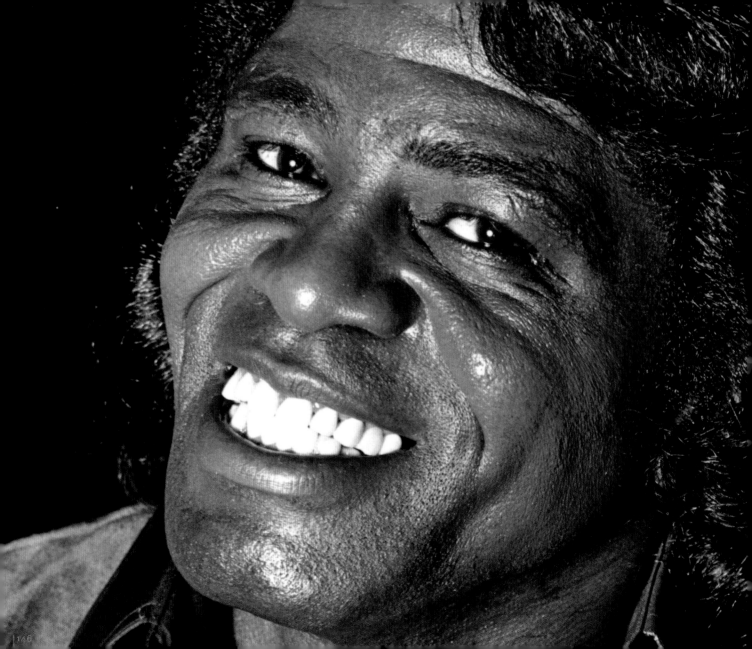

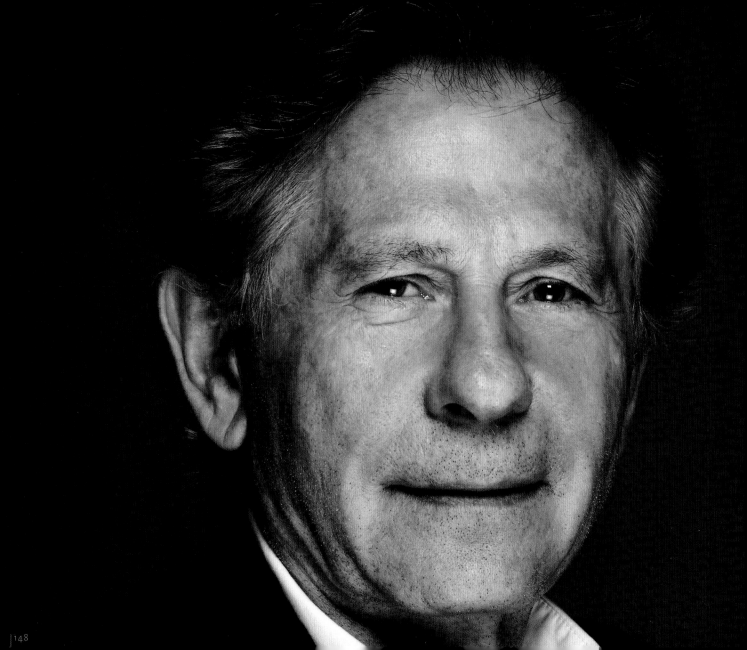

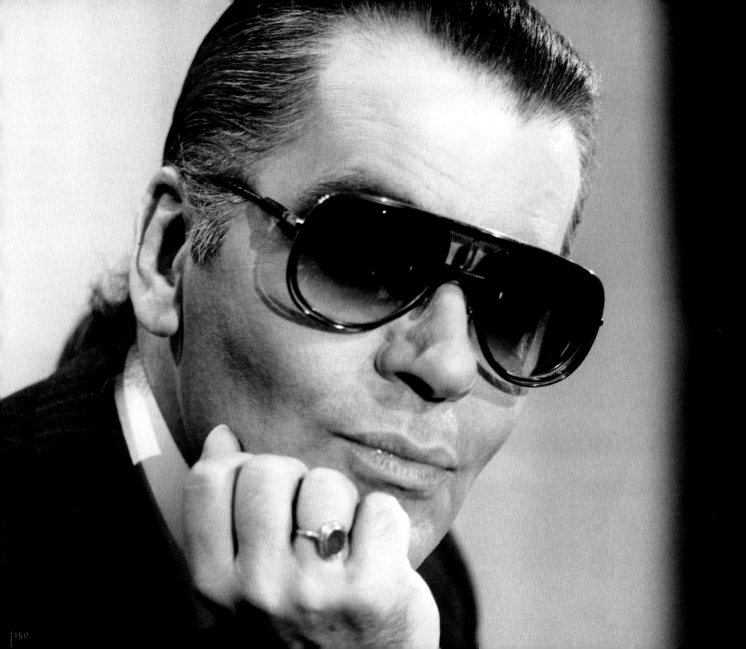

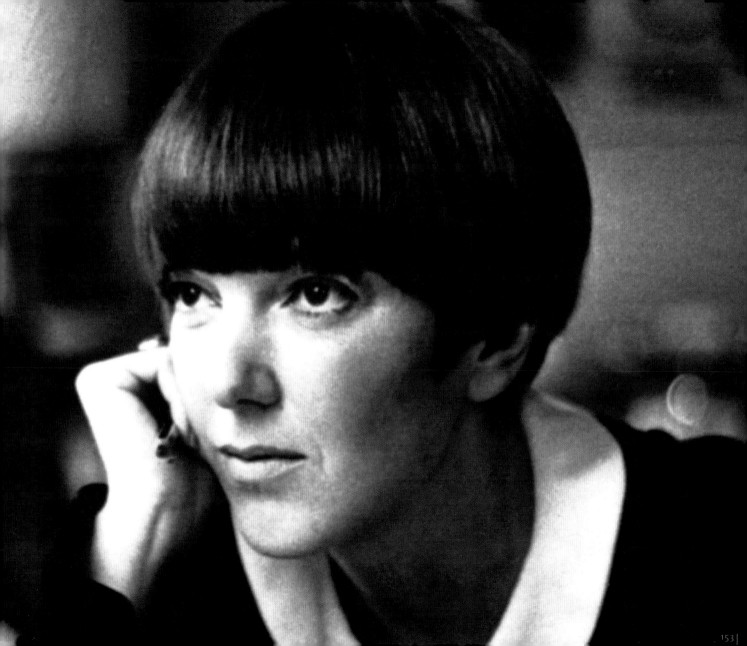

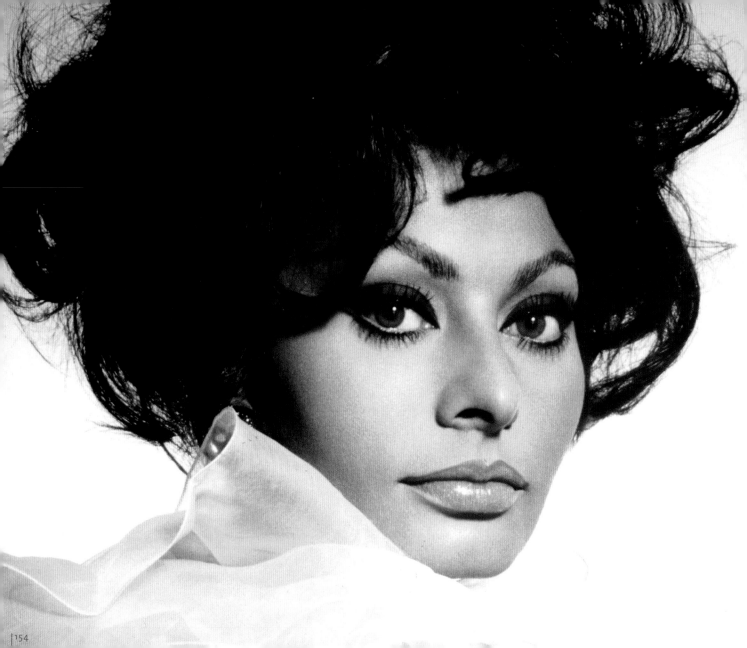

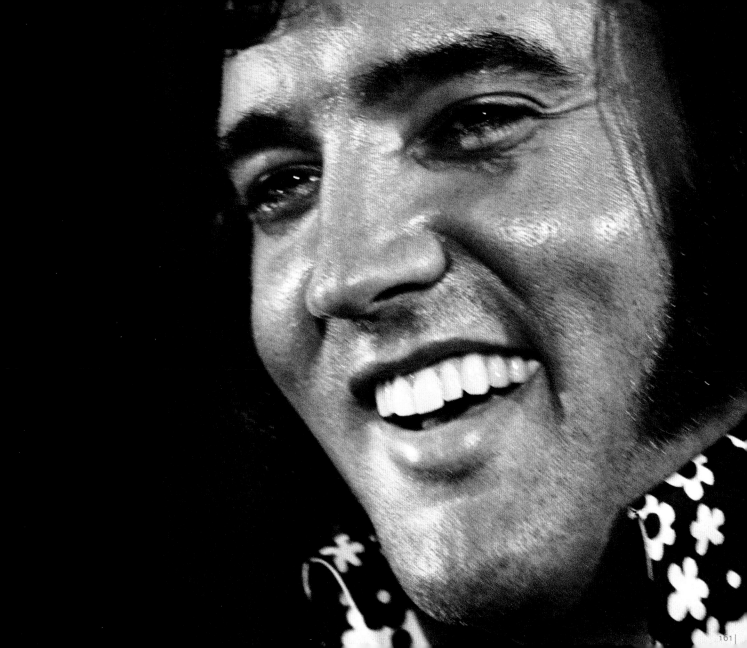

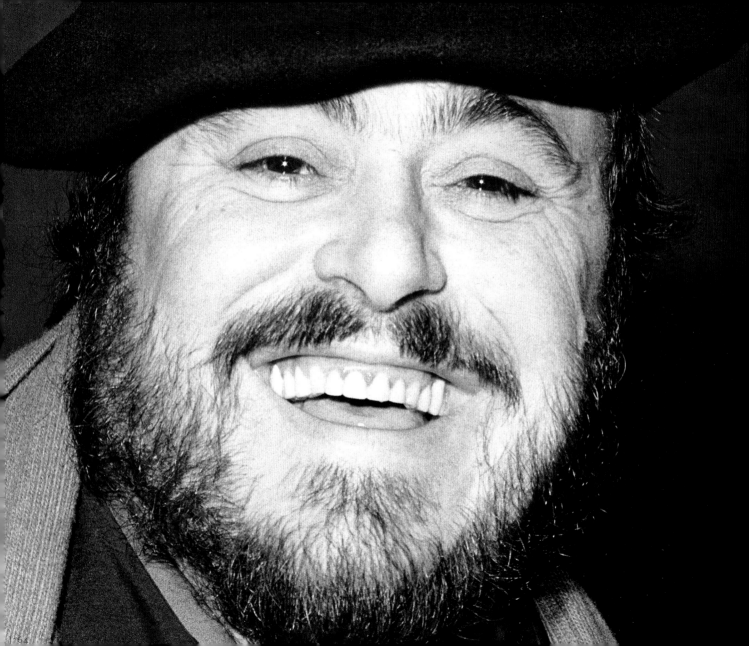

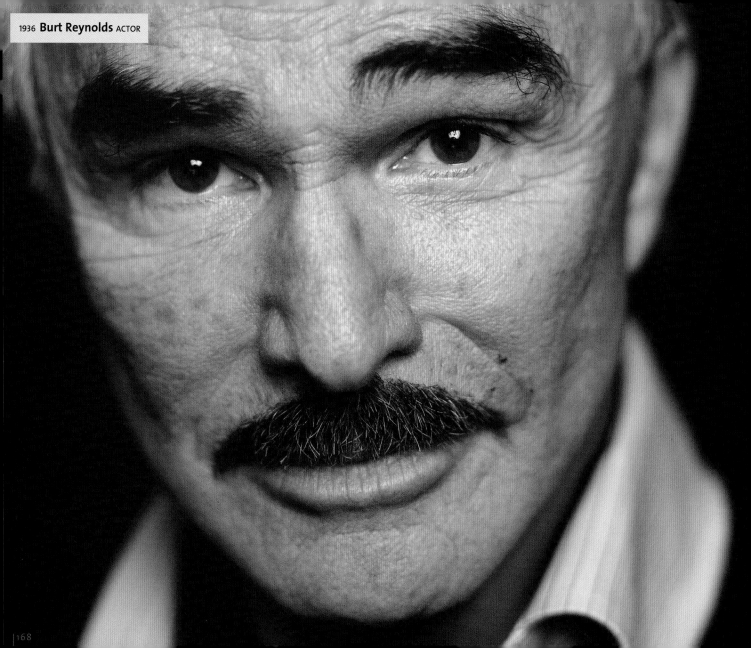

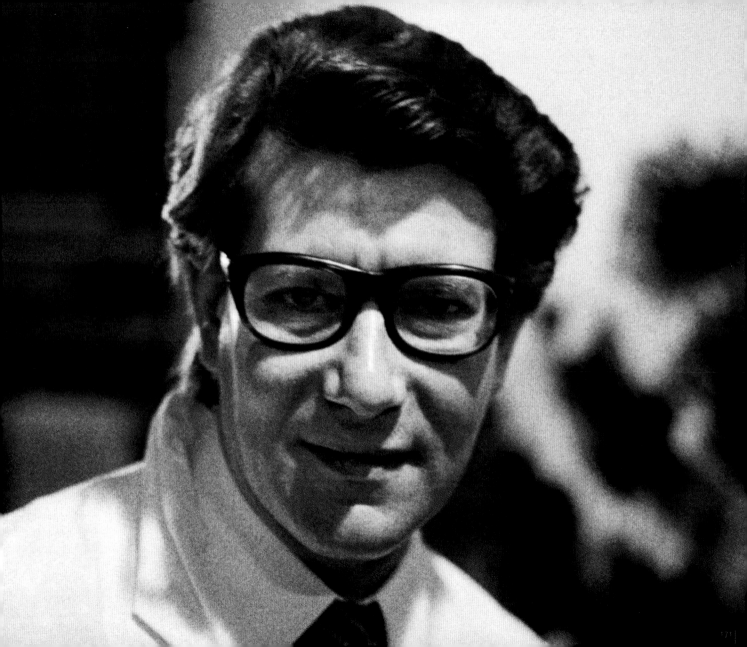

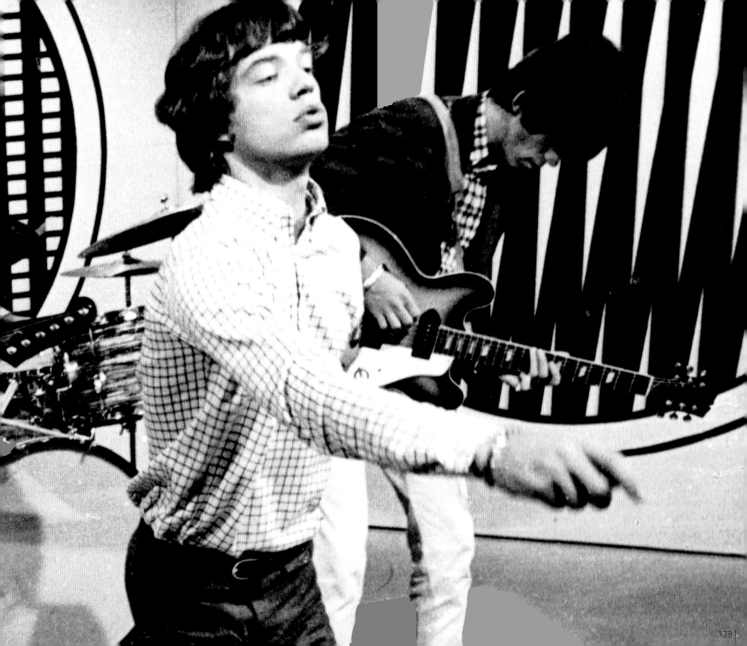

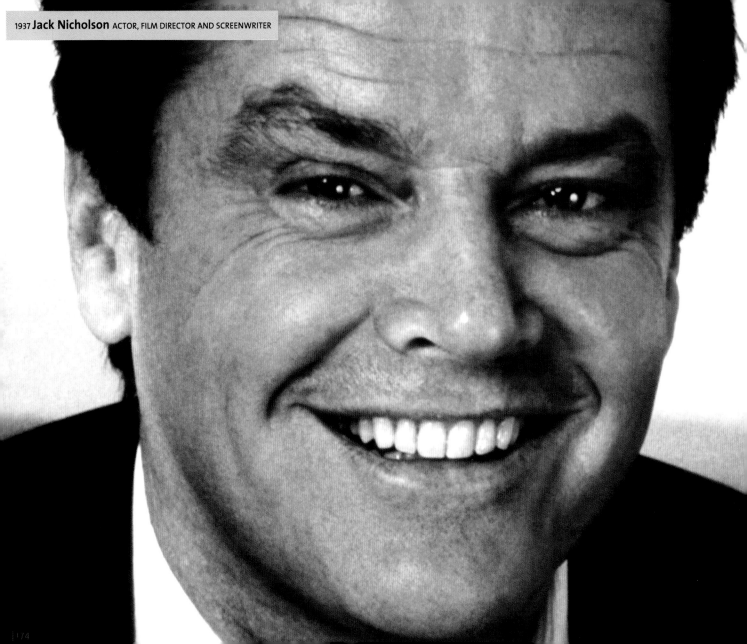

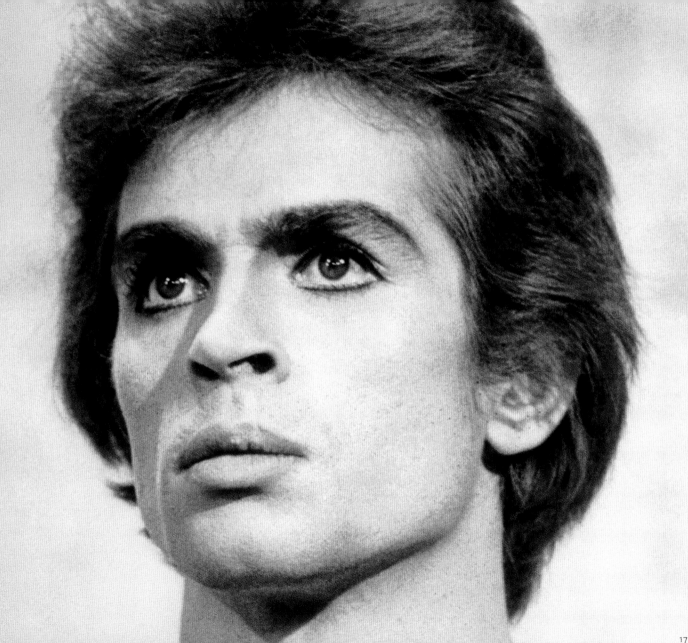

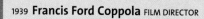

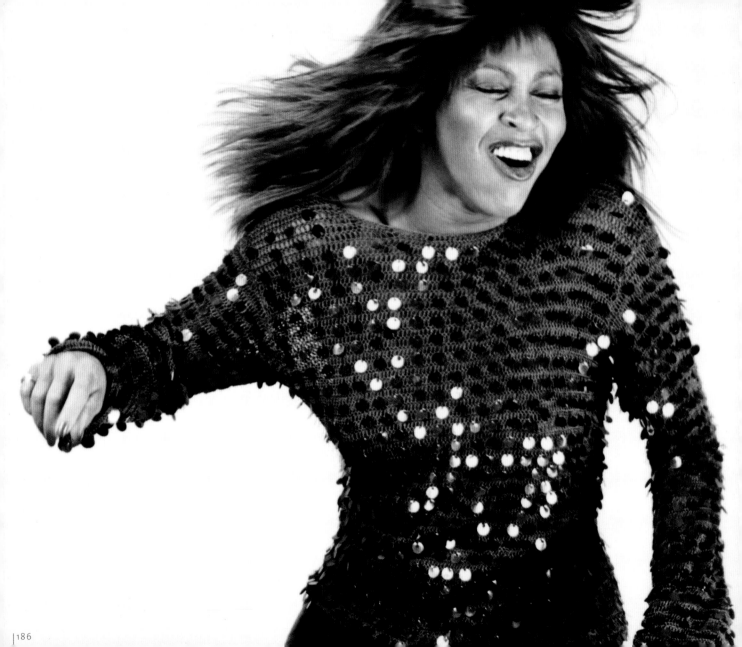

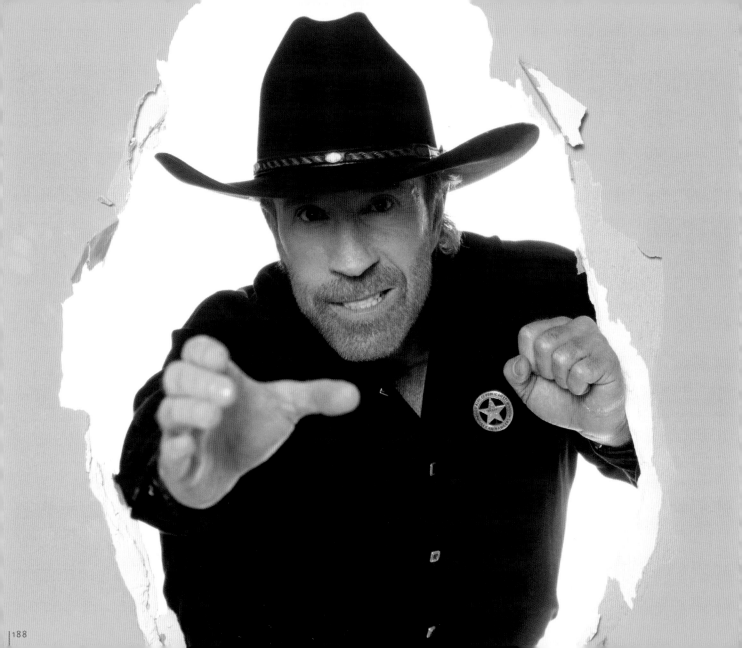

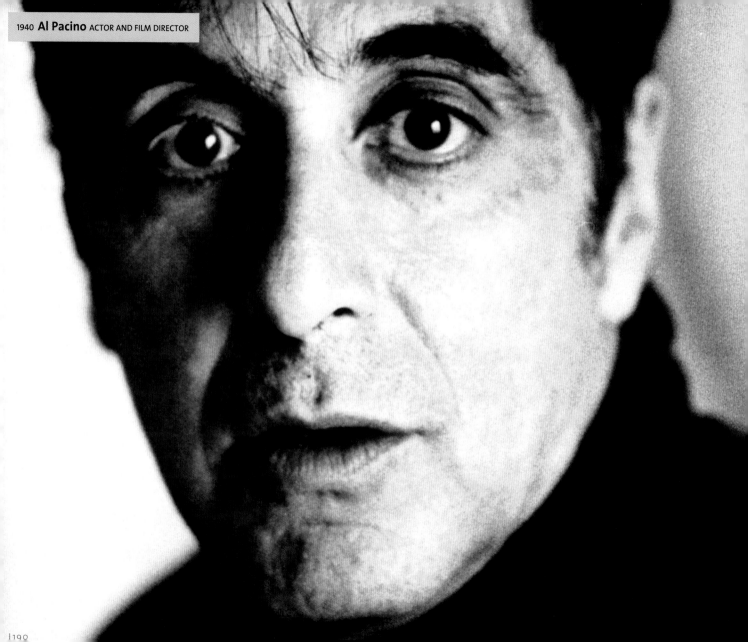

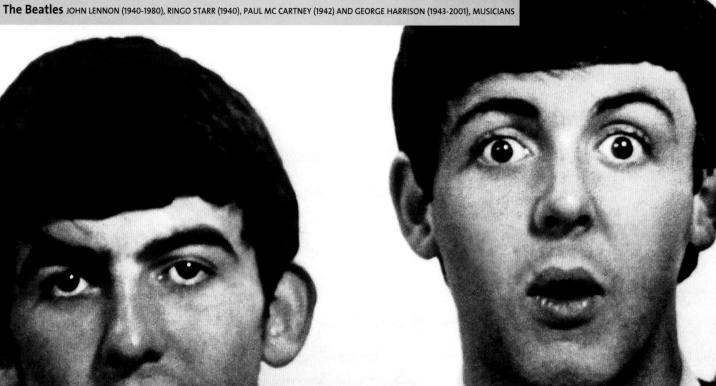

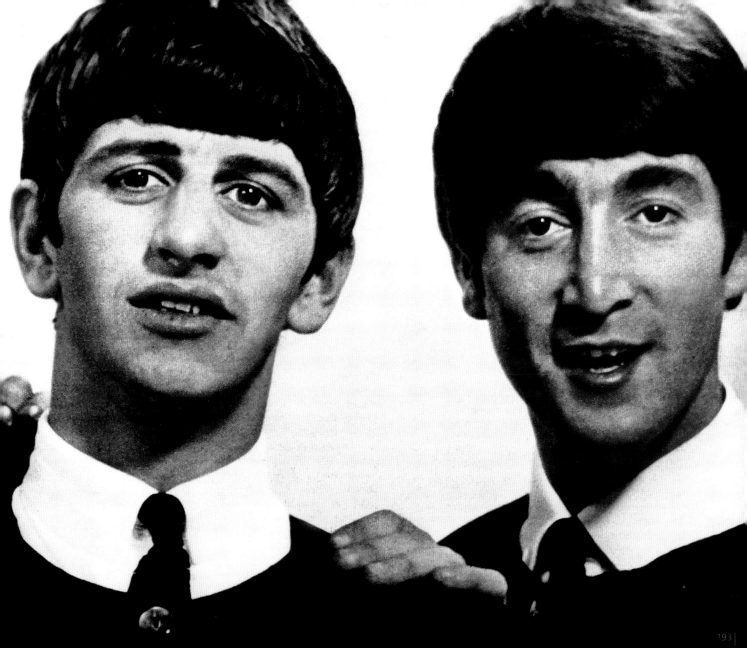

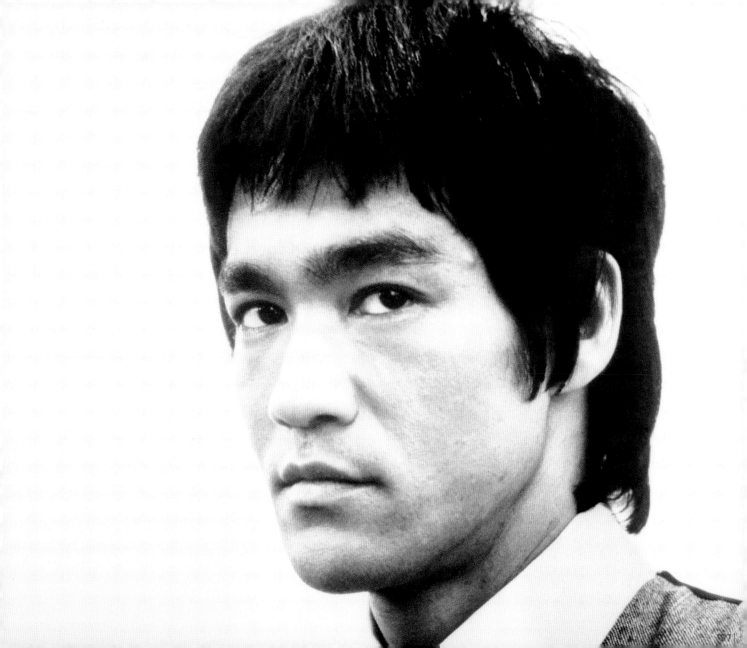

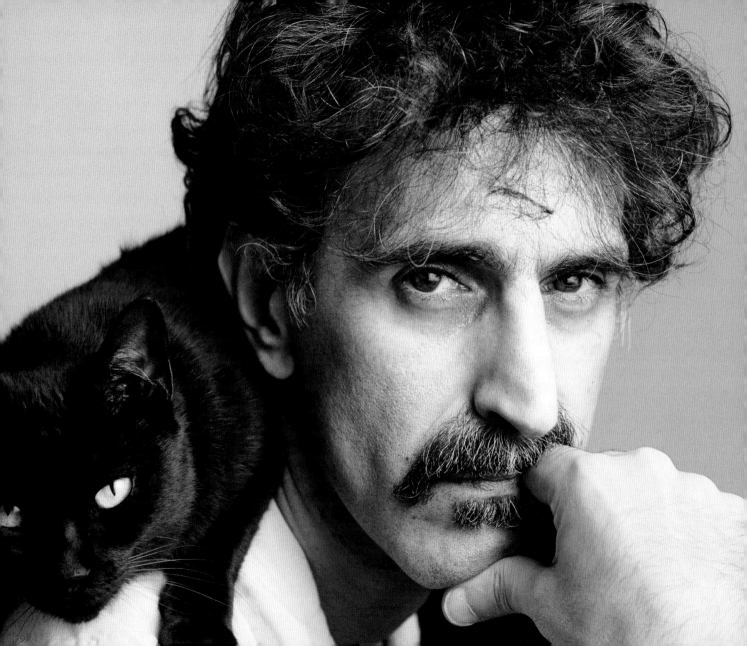

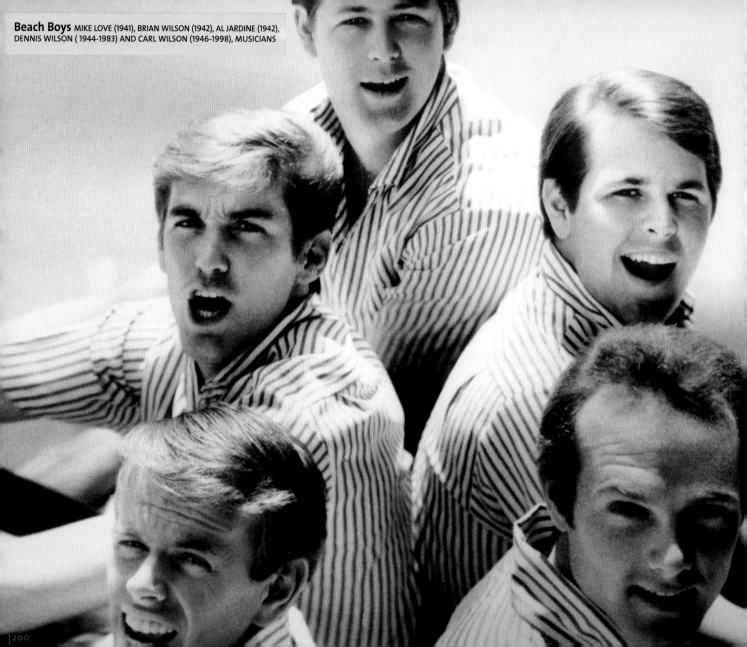

Beach Boys MIKE LOVE (1941), BRIAN WILSON (1942), AL JARDINE (1942), DENNIS WILSON (1944-1983) AND CARL WILSON (1946-1998), MUSICIANS

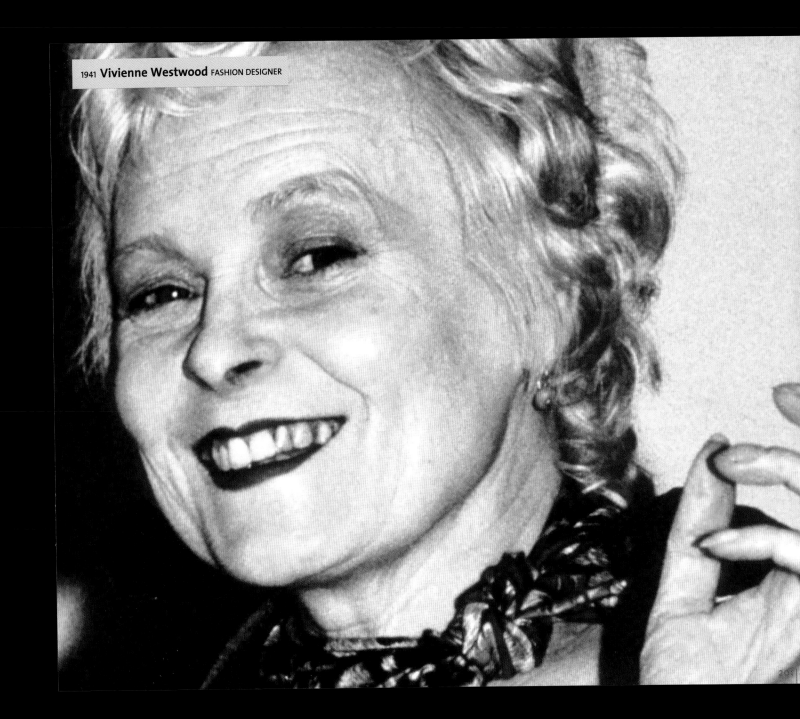

1941 **Vivienne Westwood** FASHION DESIGNER

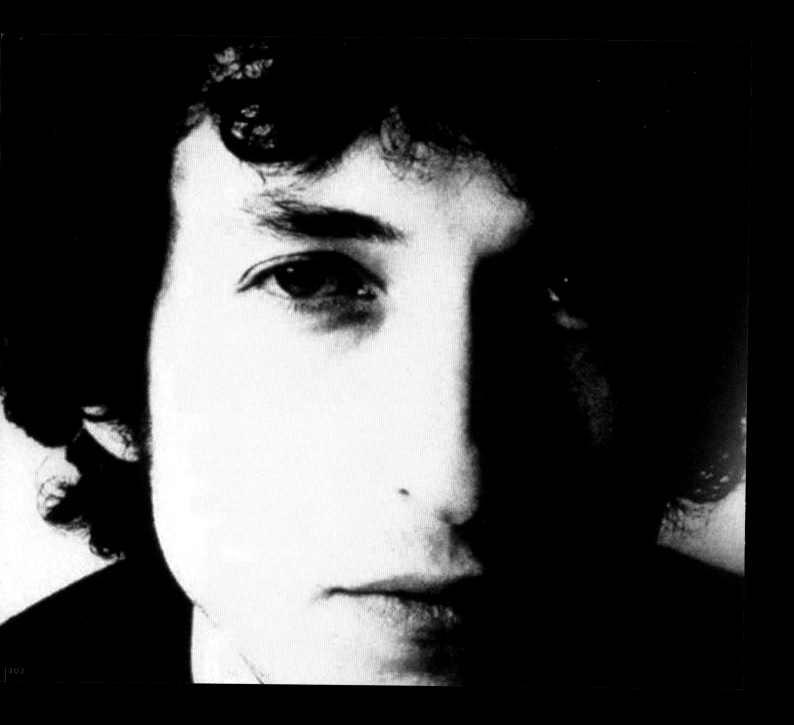

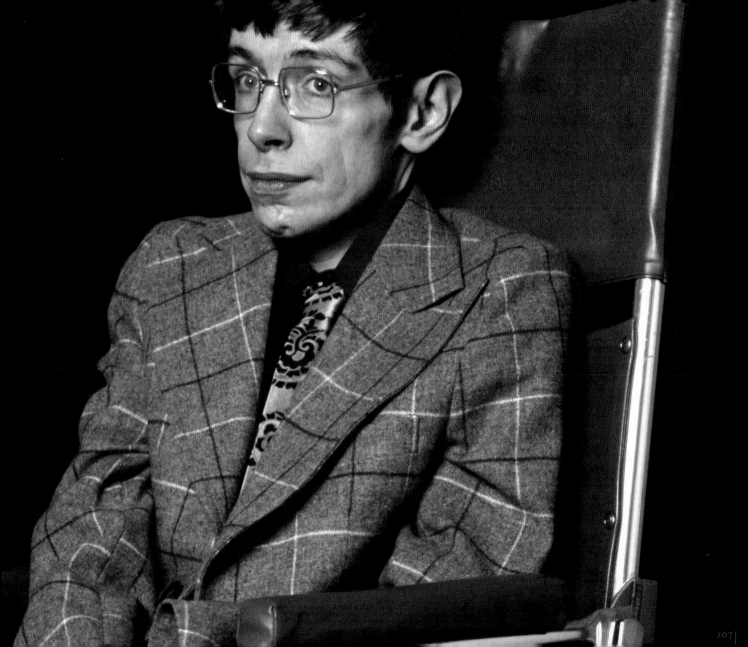

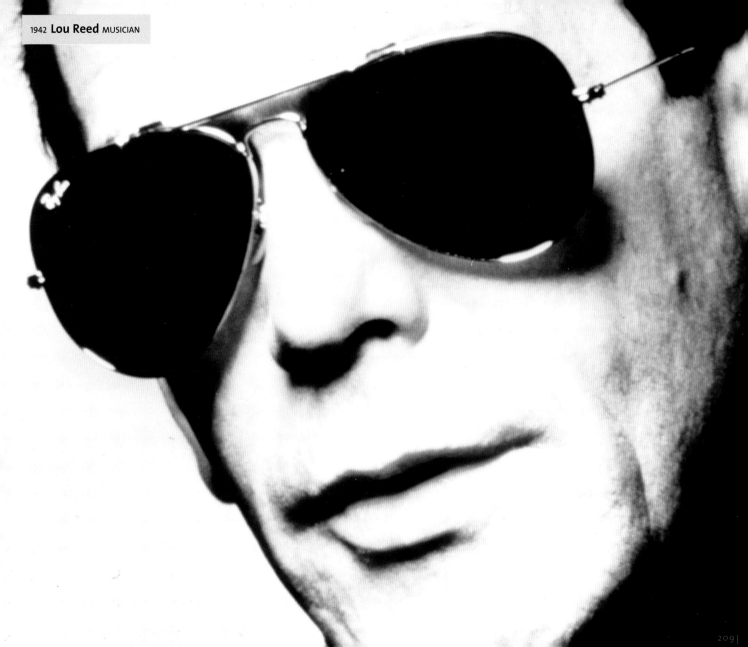

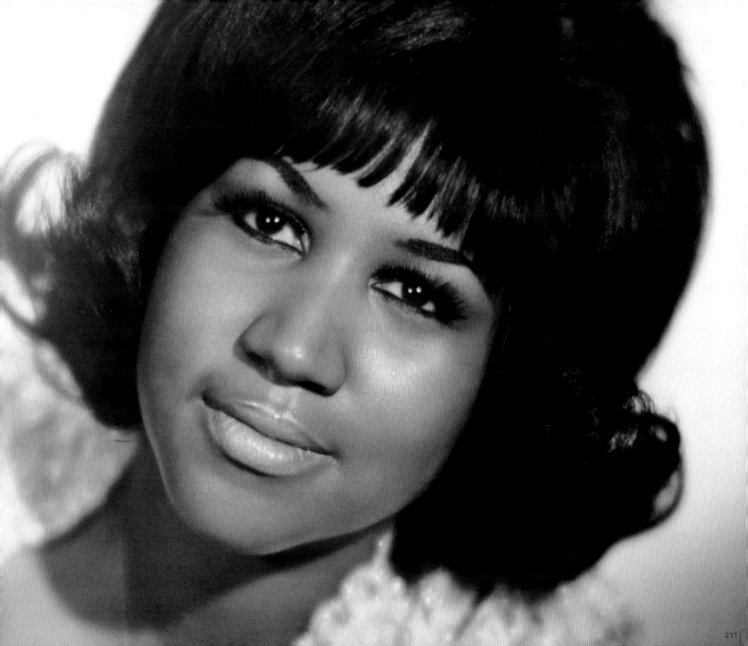

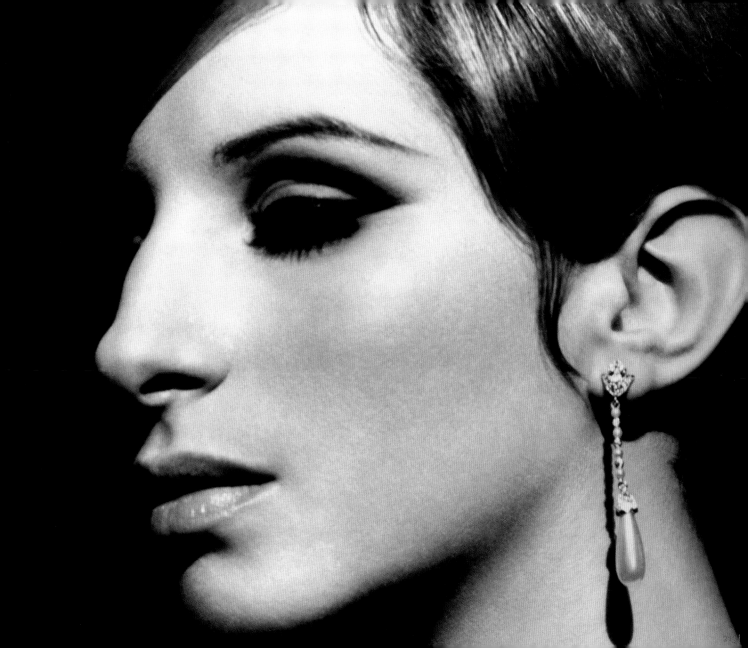

1942 **Harrison Ford** ACTOR

214

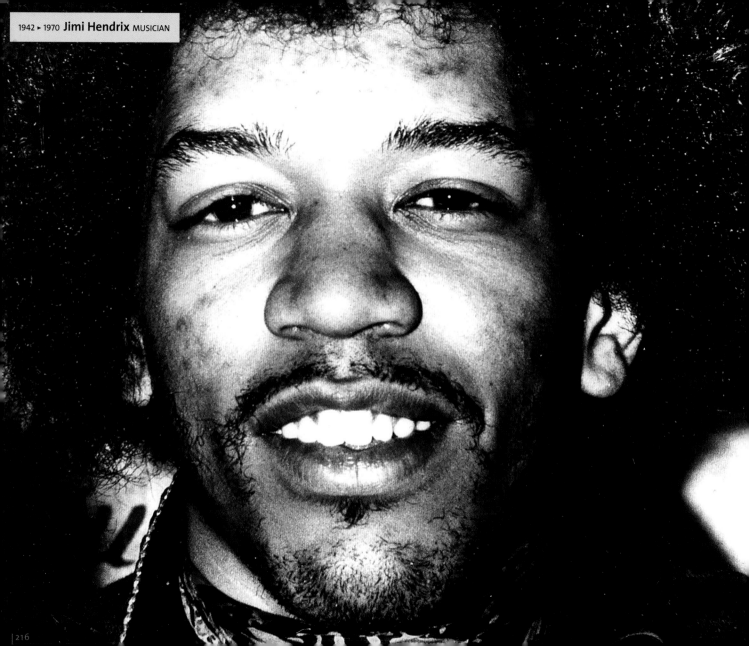

219|

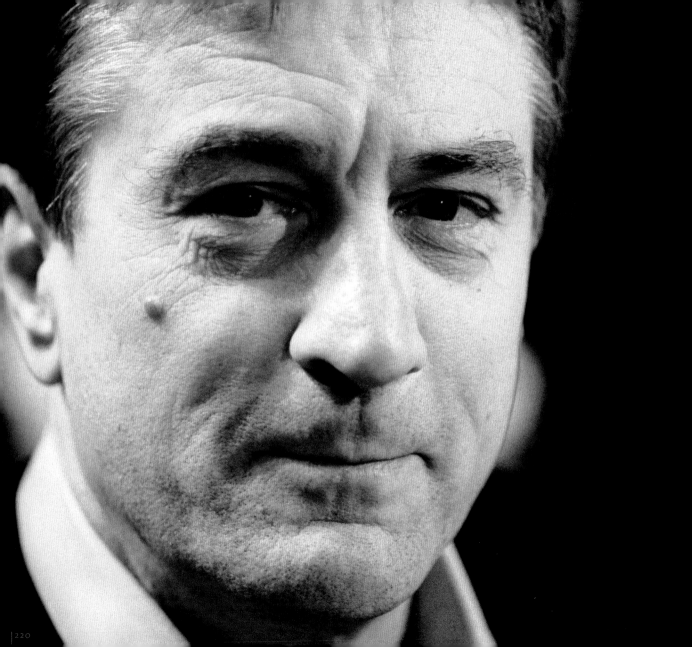

Pink Floyd ROGER WATERS (1943), RICK WRIGHT (1943-2008), NICK MASON (1944) AND SYD BARRETT (1946-2006), MUSICIANS

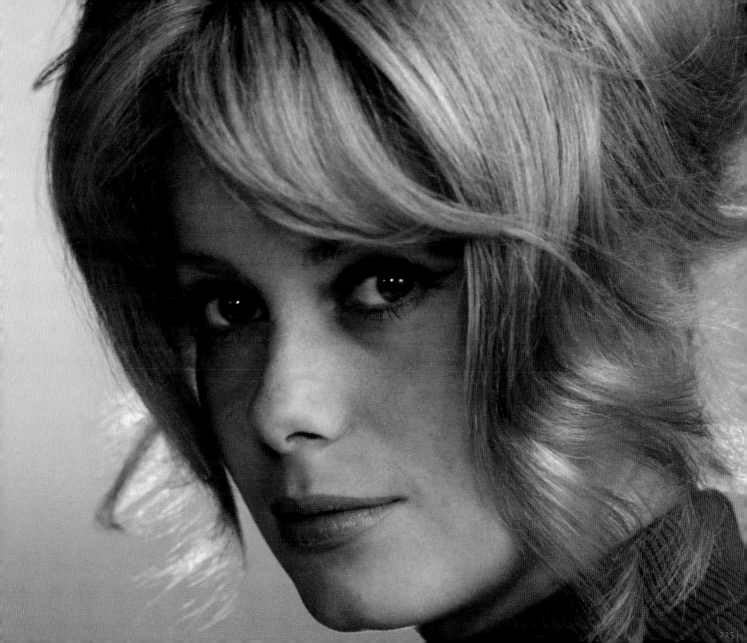

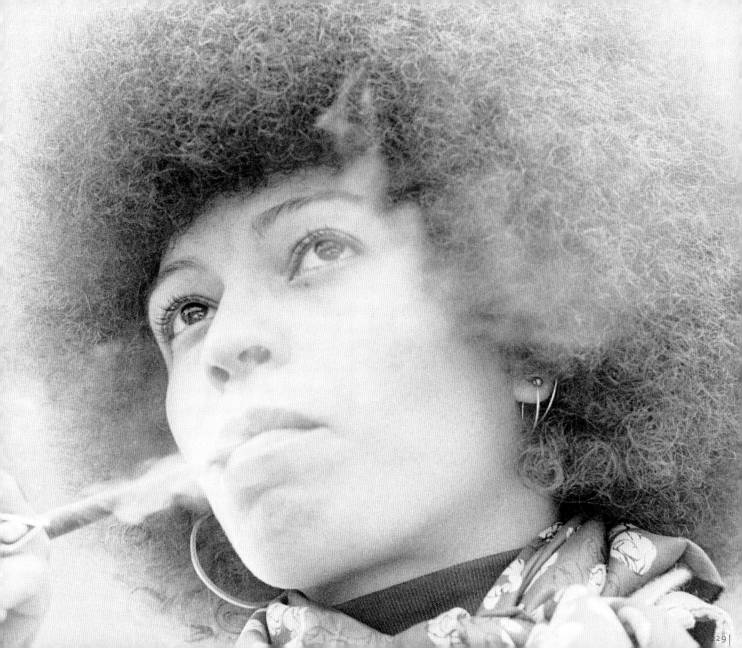

The Who ROGER DALTREY (1944), JOHN ENTWISTLE (1944-2002), PETE TOWNSHEND (1945) AND KEITH MOON (1946-1978), MUSICIANS

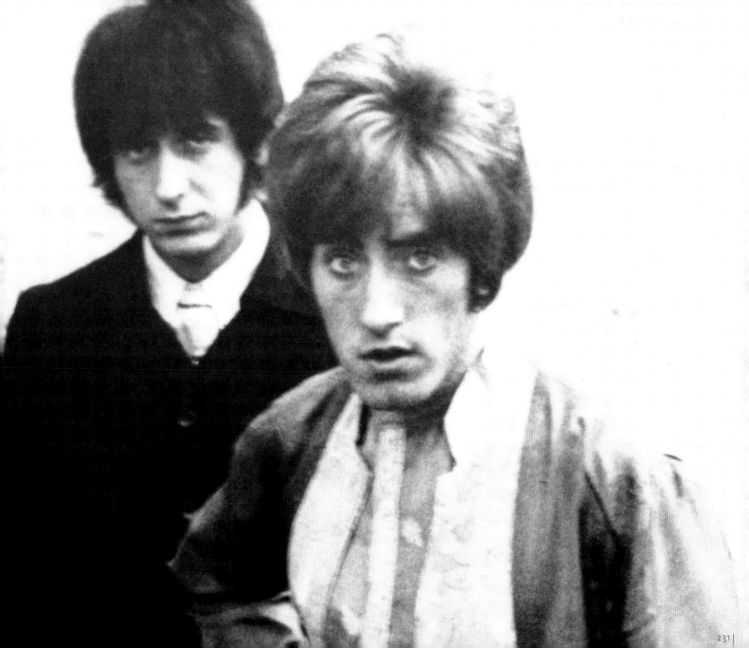

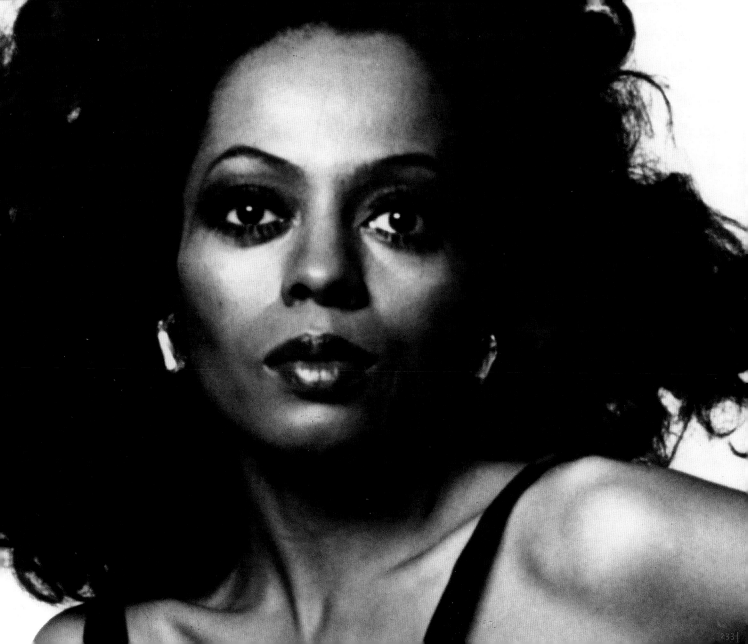

ABBA ANNI-FRID LYNGSTAD (1945), BJÖRN ULVAEUS (1945),
BENNY ANDERSSON (1946) AND AGNETHA FÄLTSKOG (1950), MUSICIANS

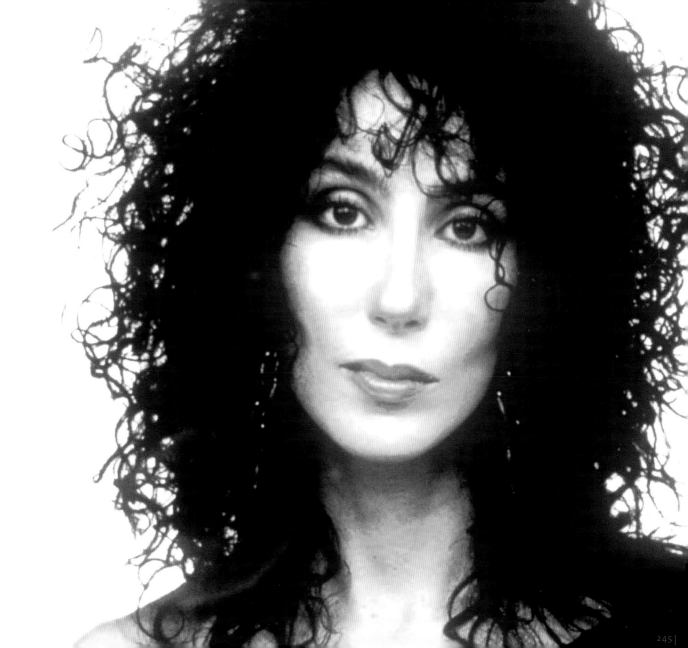

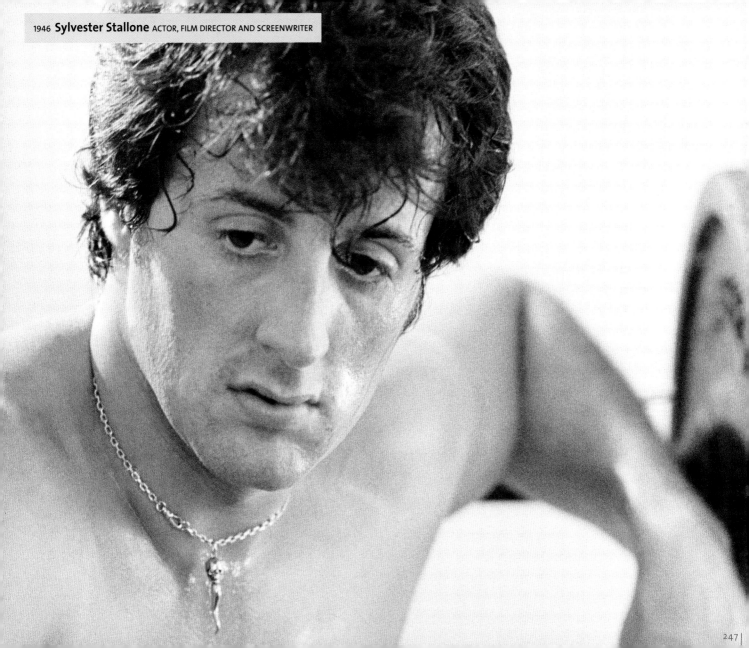

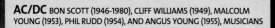

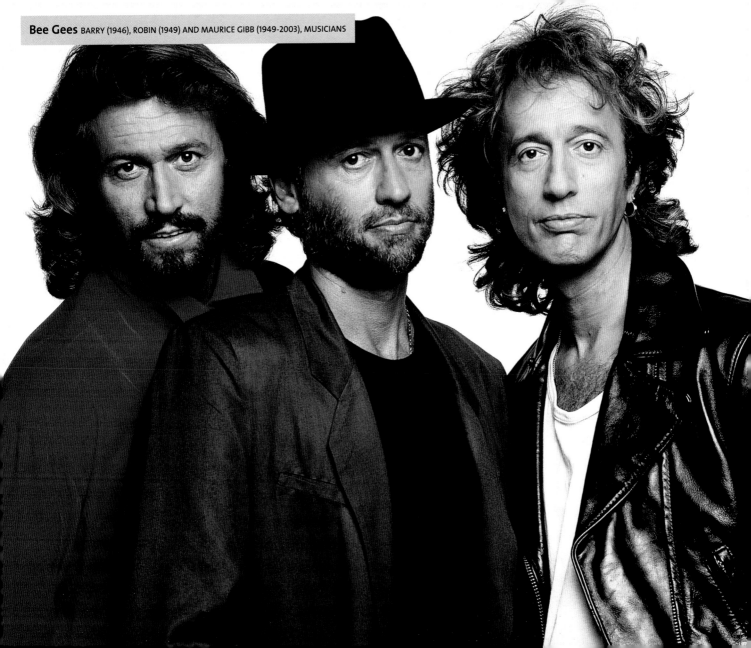

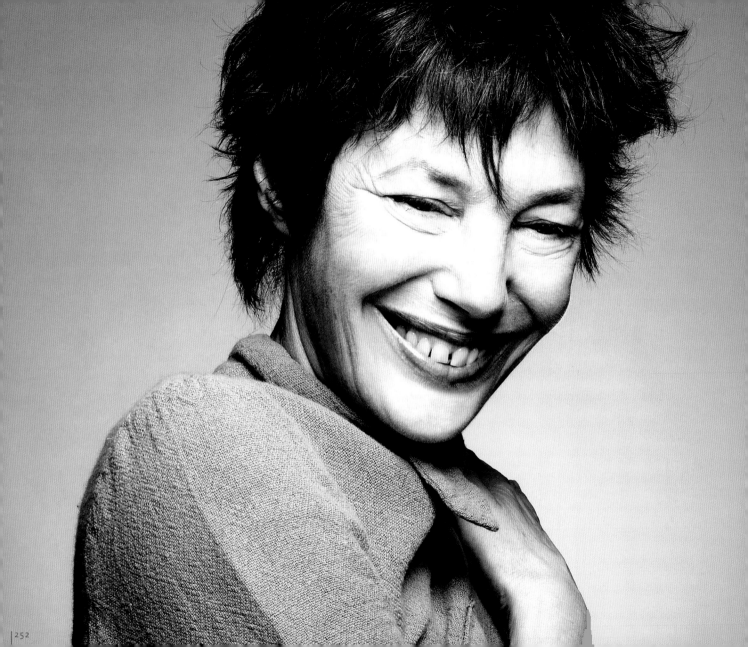

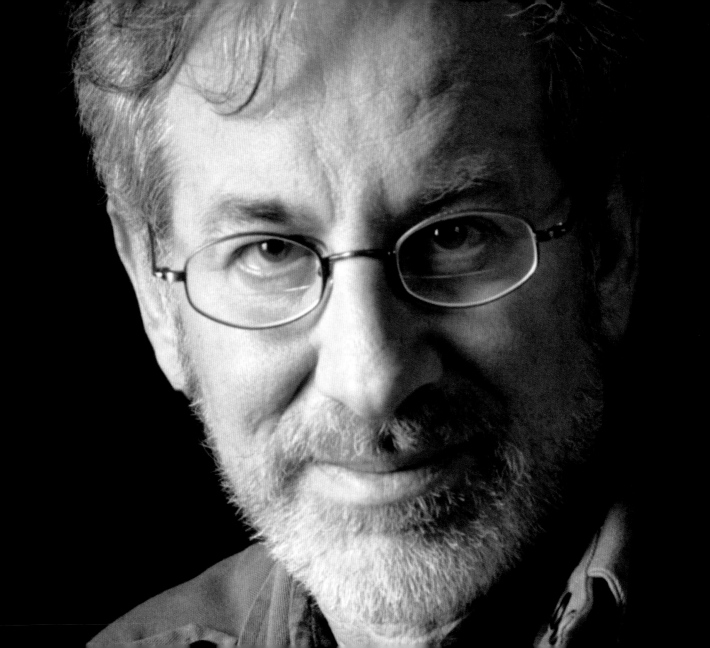

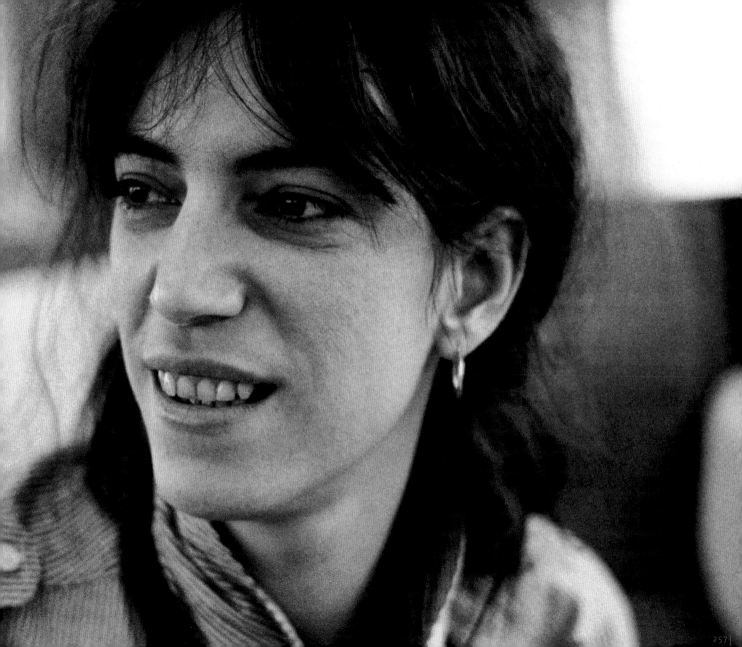

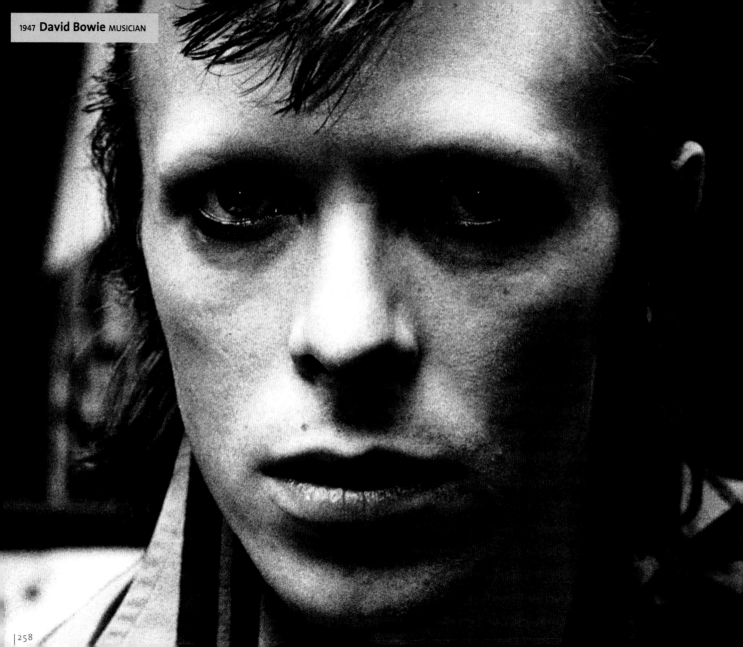

2596

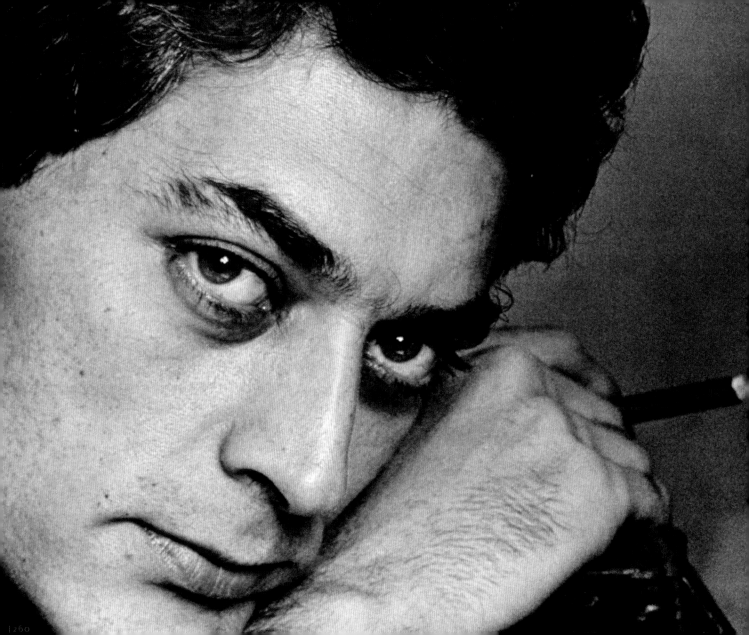

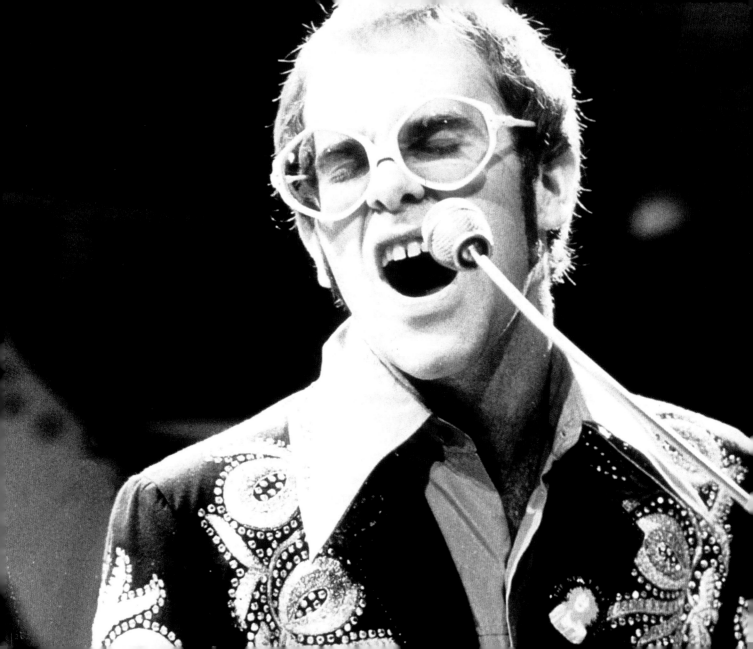

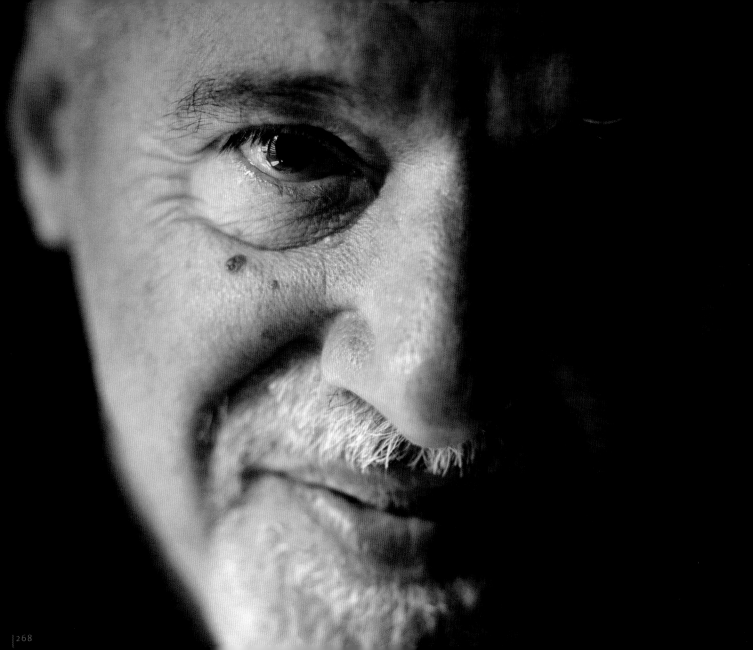

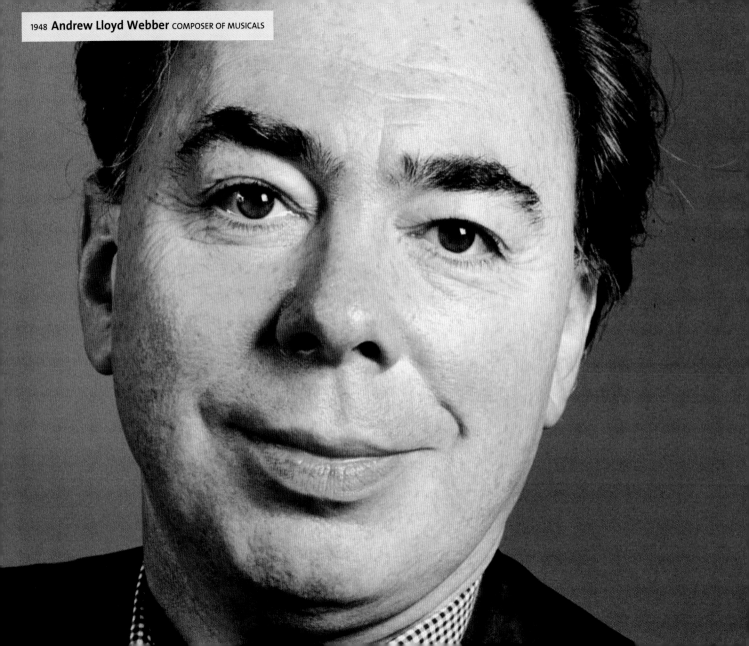

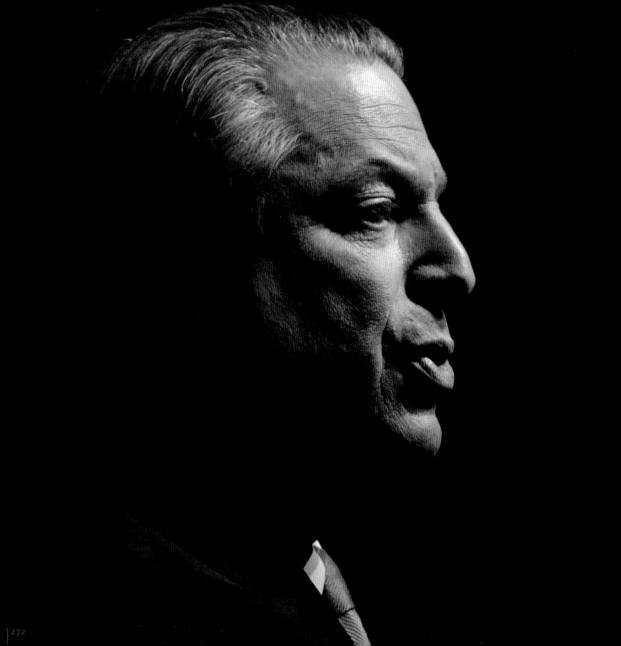

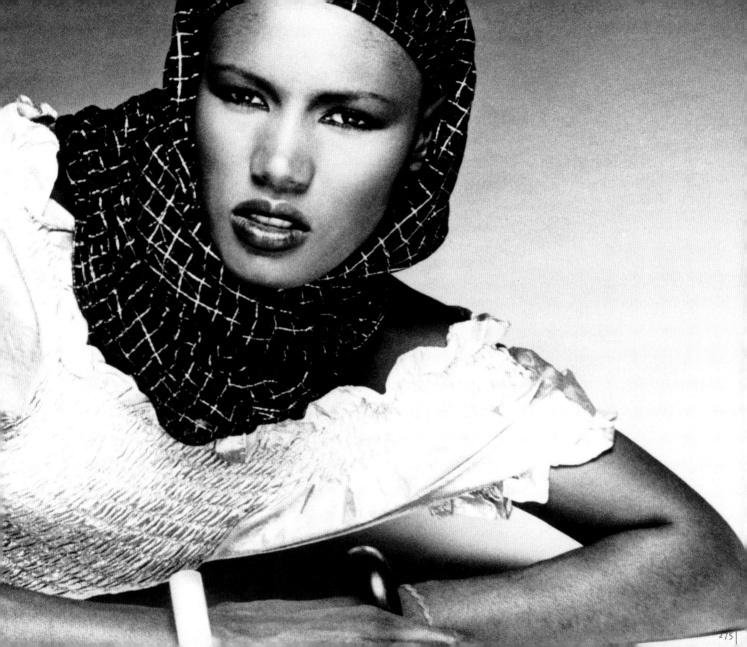

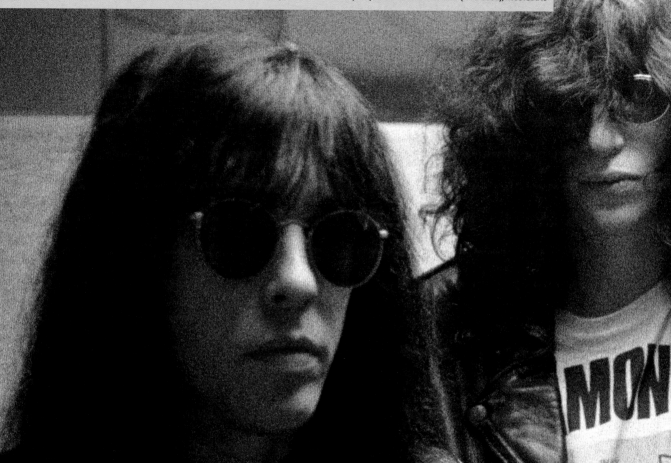

The Ramones JOHNNY RAMONE (1948-2004), JOEY RAMONE (1951-2004), TOMMY RAMONE (1952) AND DEE DEE RAMONE (1952-2002), MUSICIANS

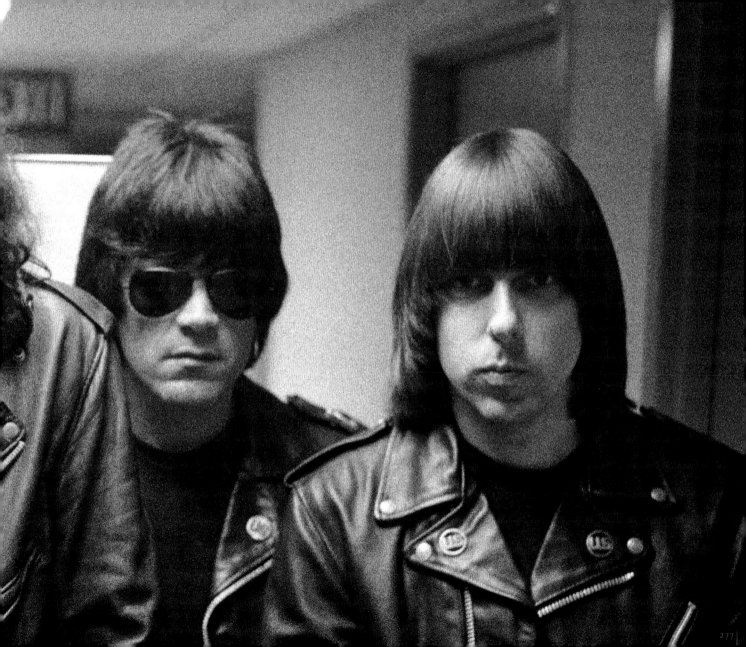

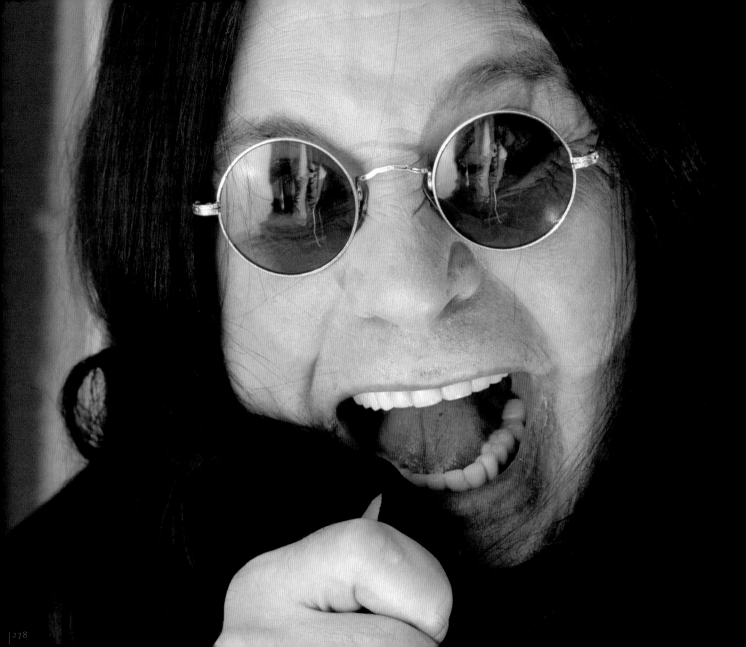

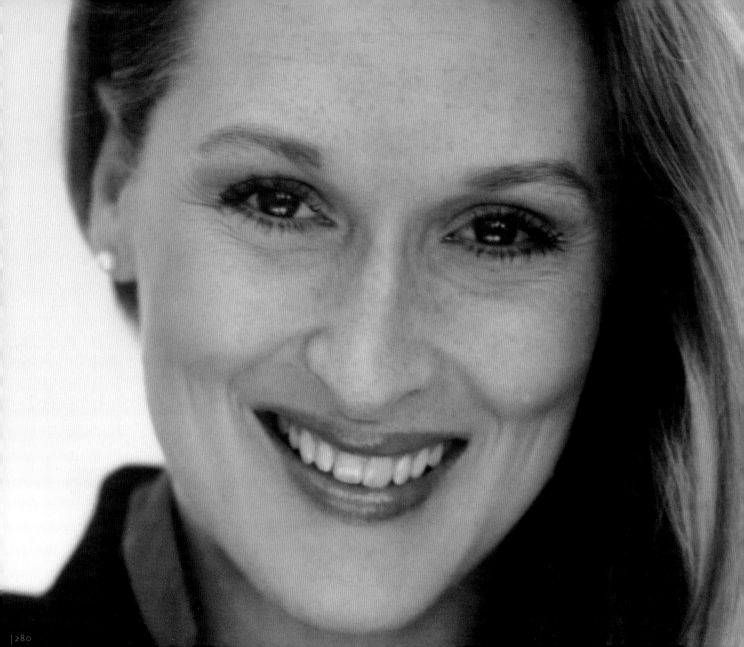

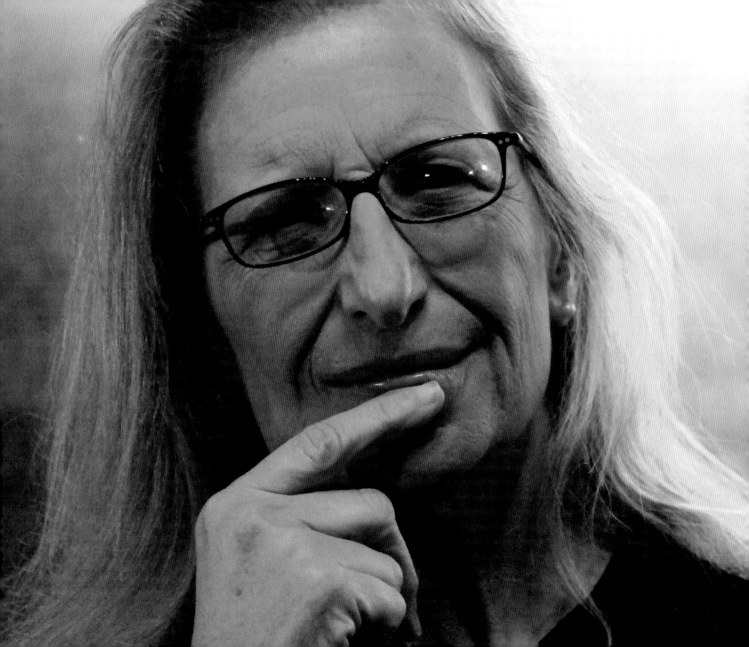

285

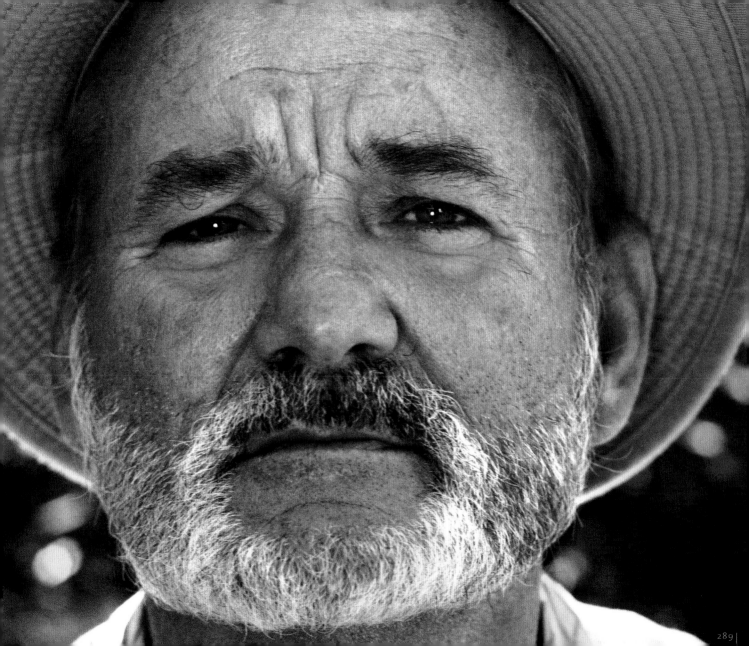

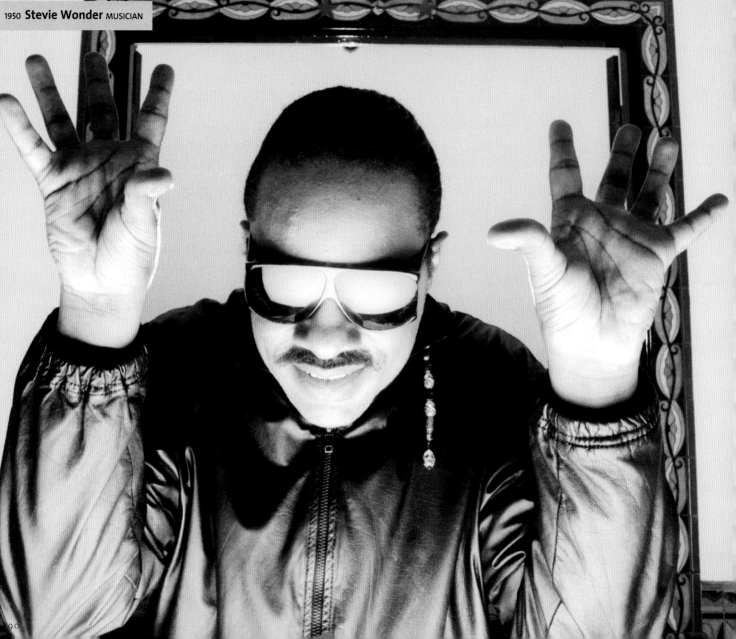

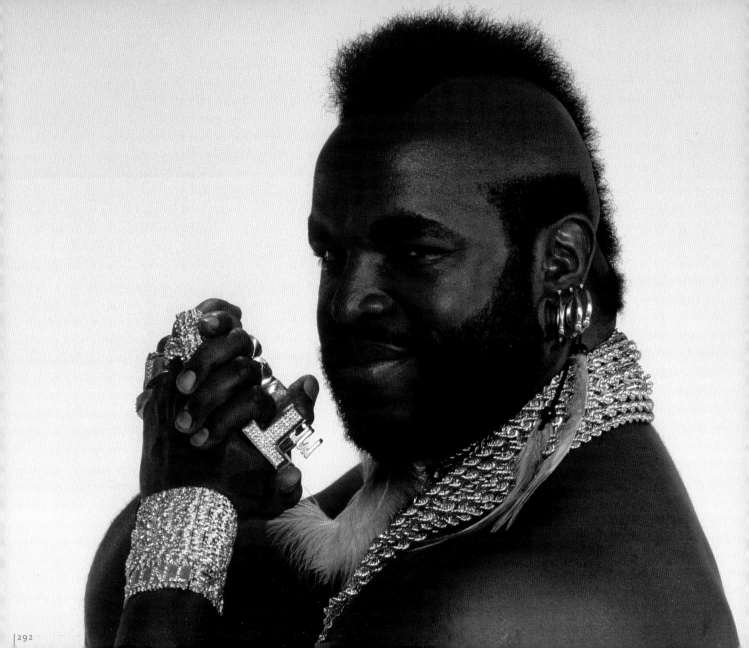

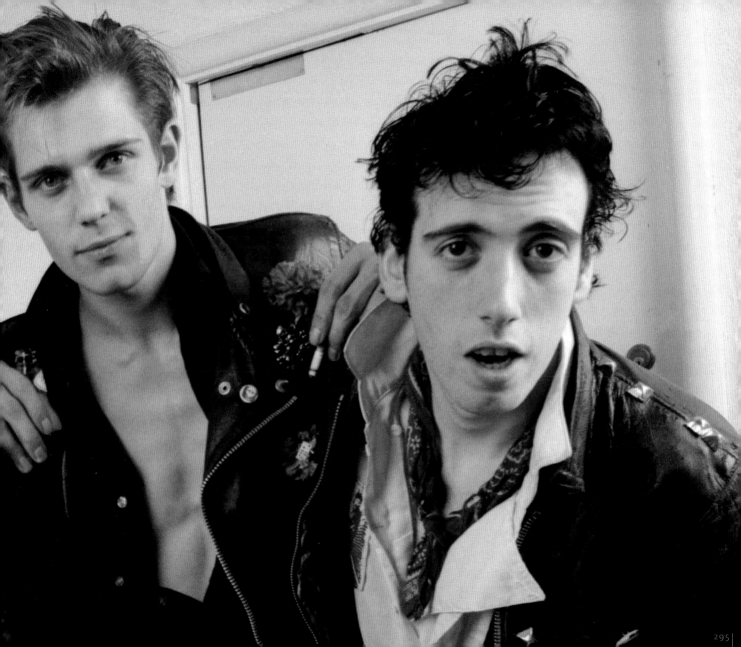

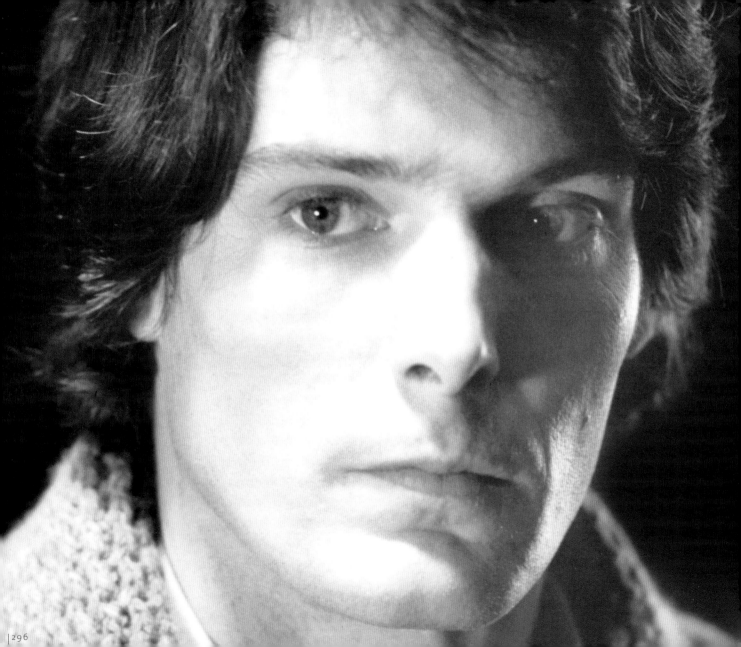

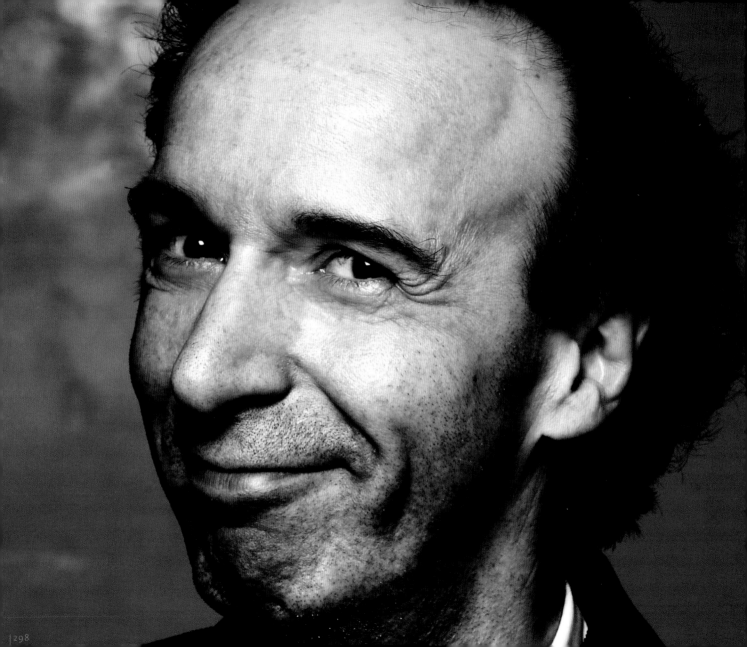

1953 **Jim Jarmusch** FILM DIRECTOR

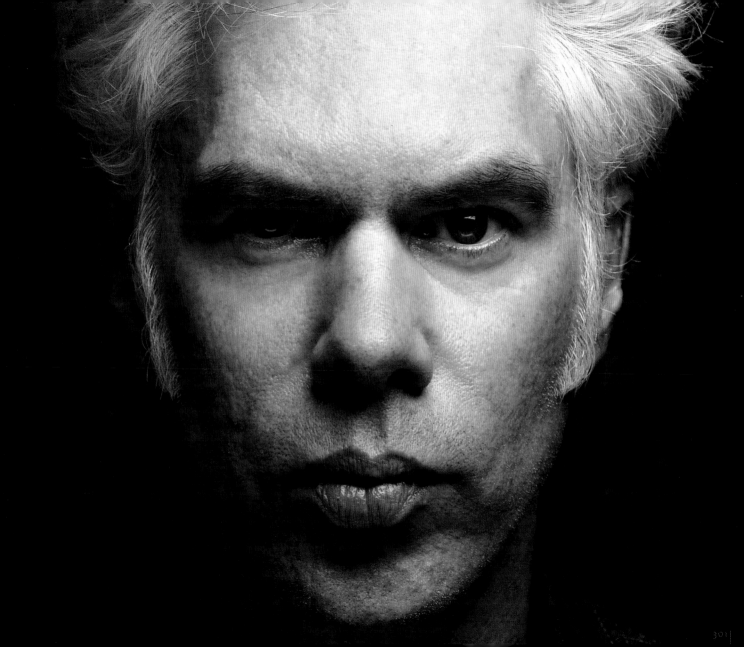

1954 **Matt Groening** CARTOONIST, TELEVISION PRODUCER AND WRITER

395

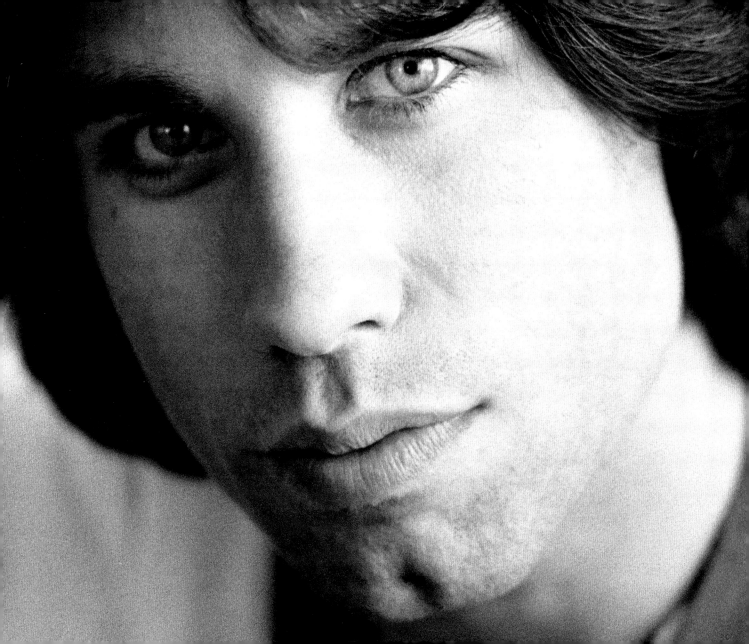

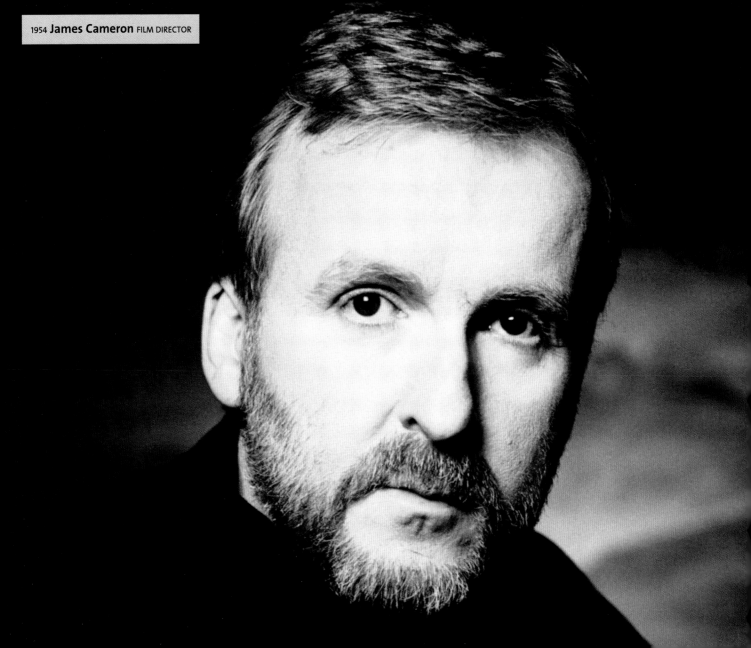

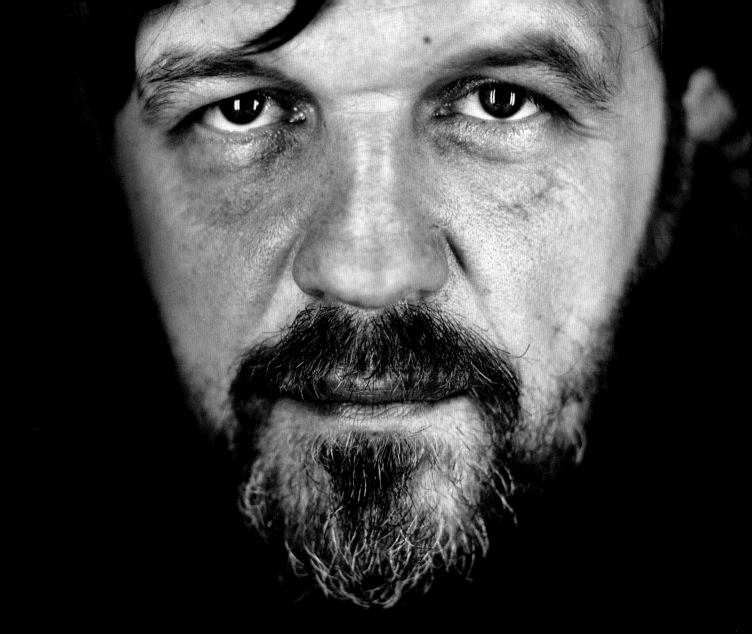

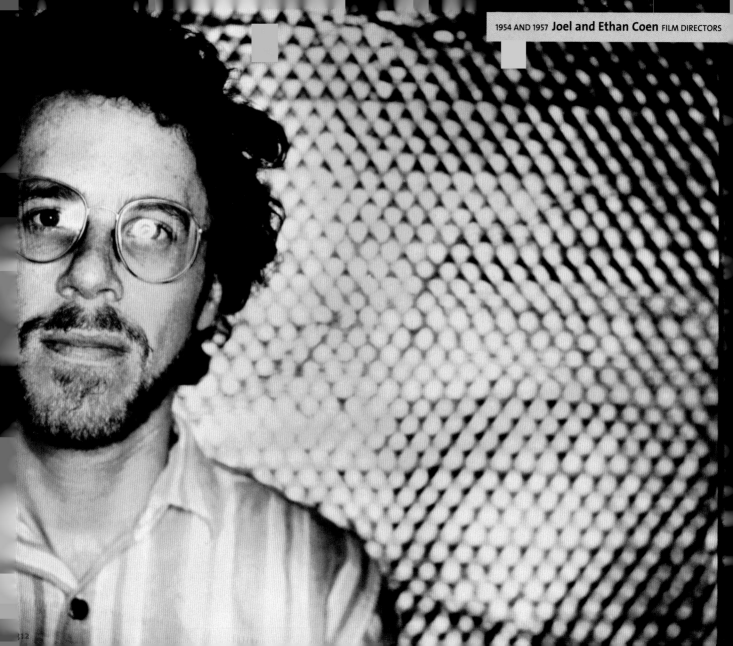

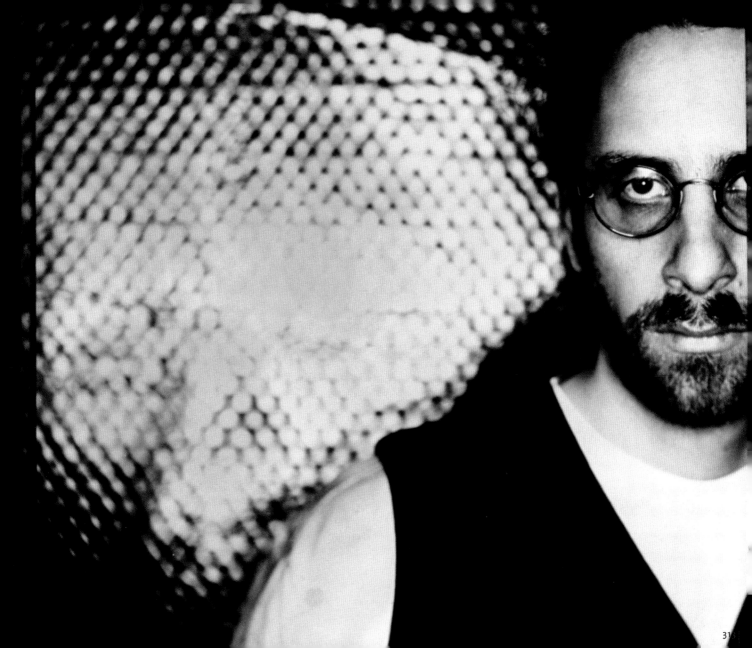

Sex Pistols STEVE JONES (1955), PAUL COOK (1956), GLEN MATLOCK (1956) AND JOHNNY ROTTEN (1957), MUSICIANS

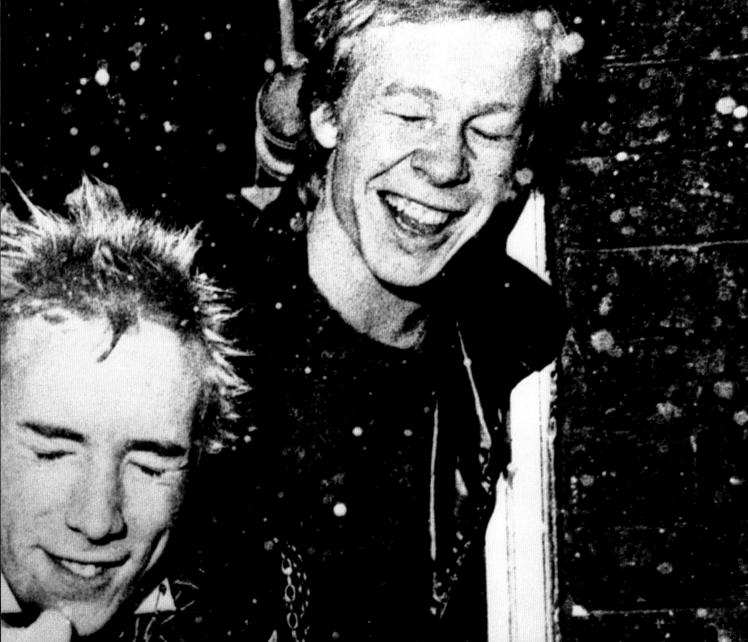

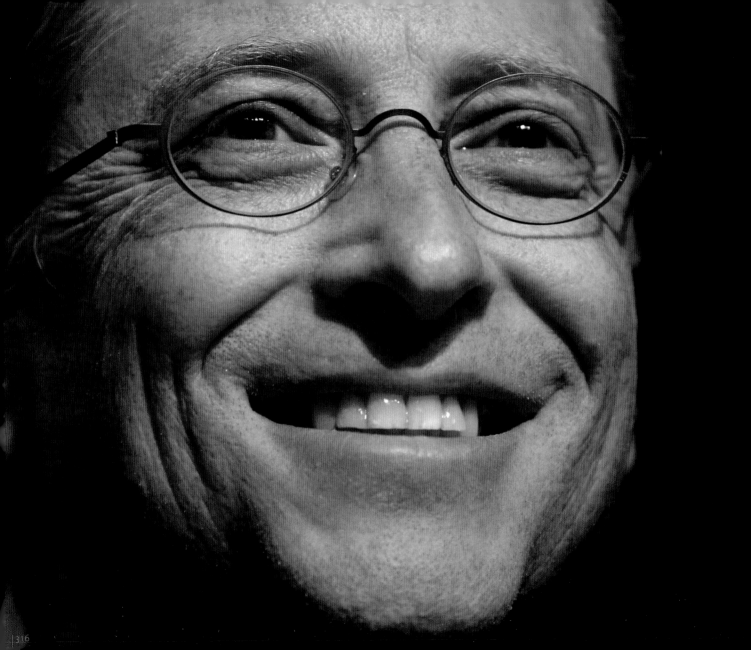

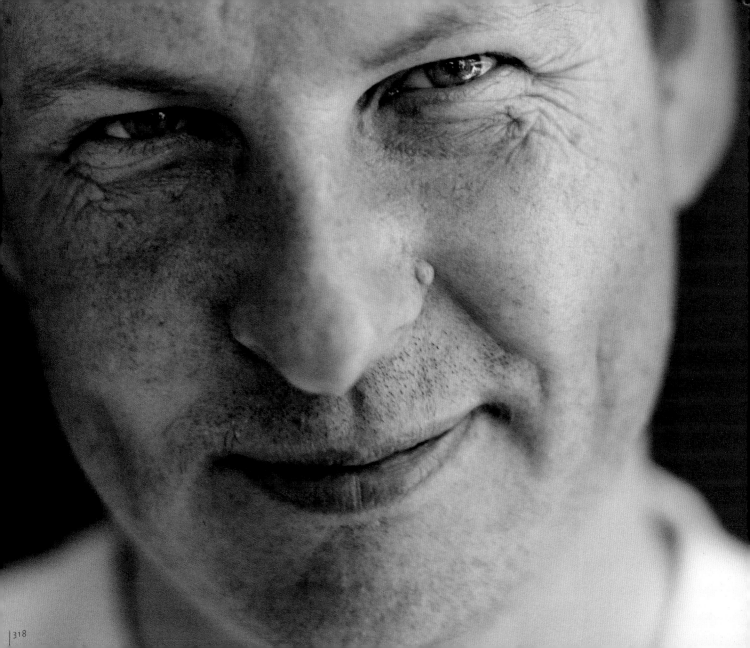

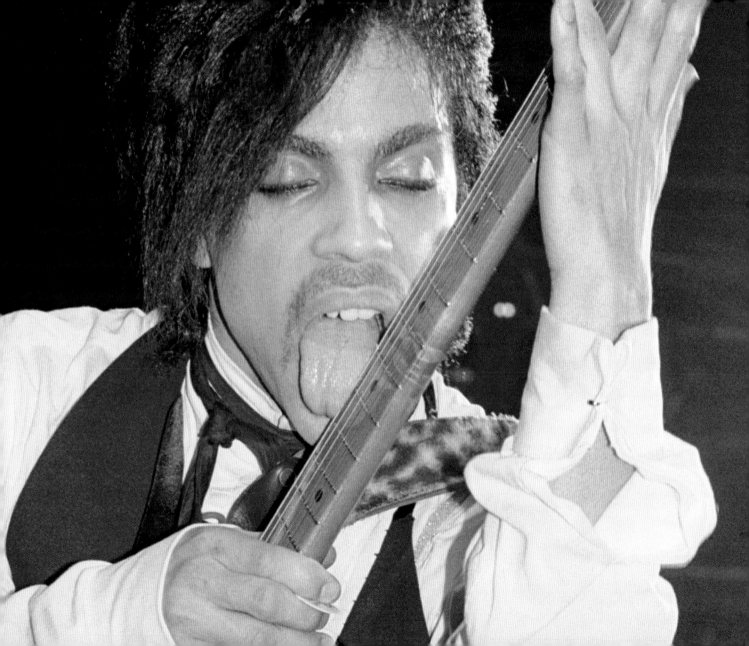

1958 **Madonna** MUSICIAN AND ACTRESS

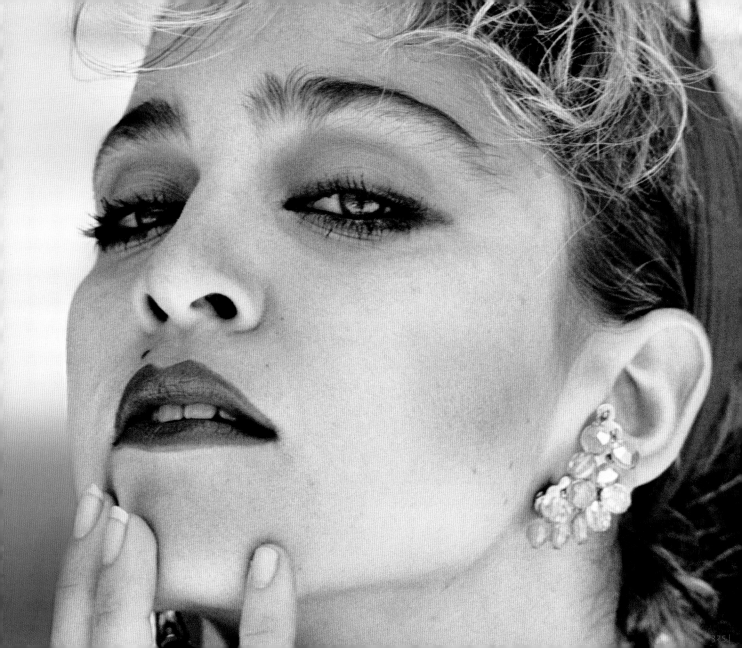

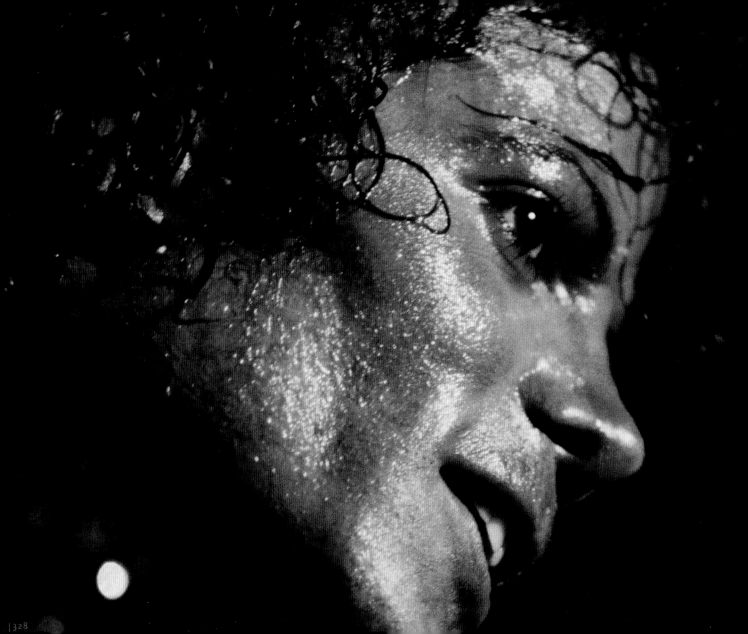

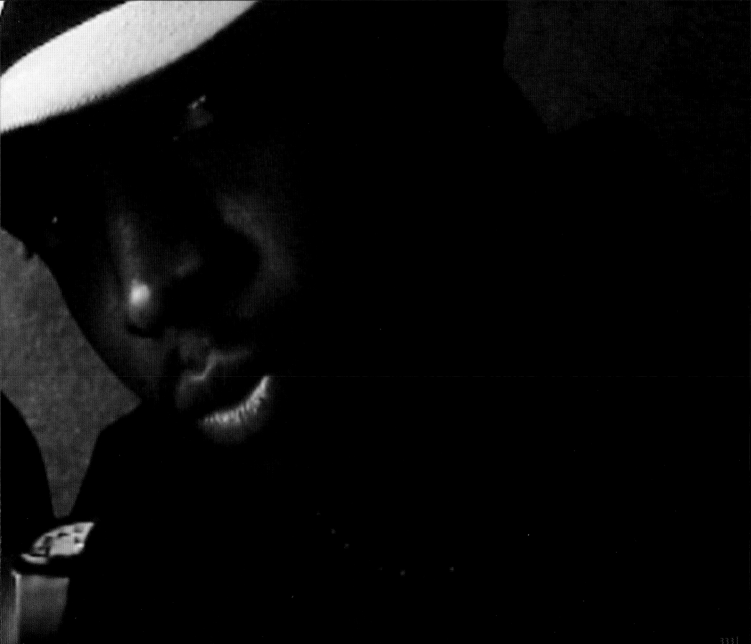

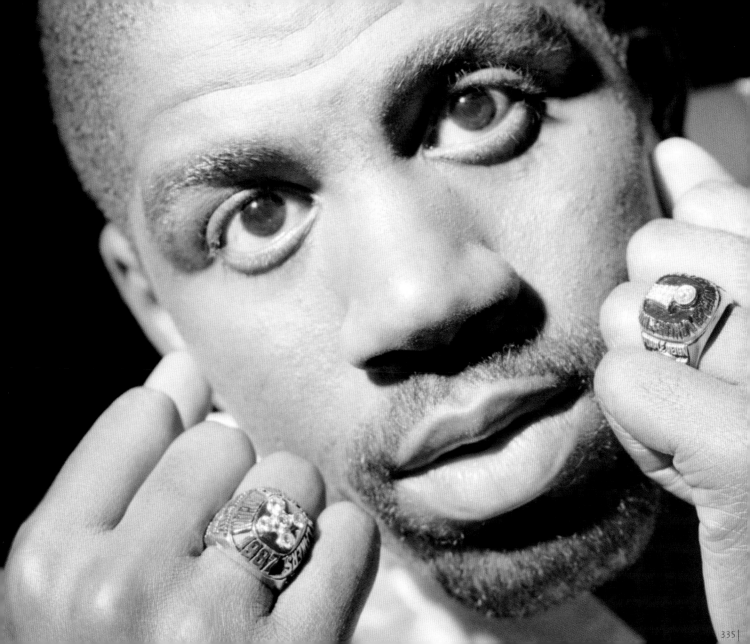

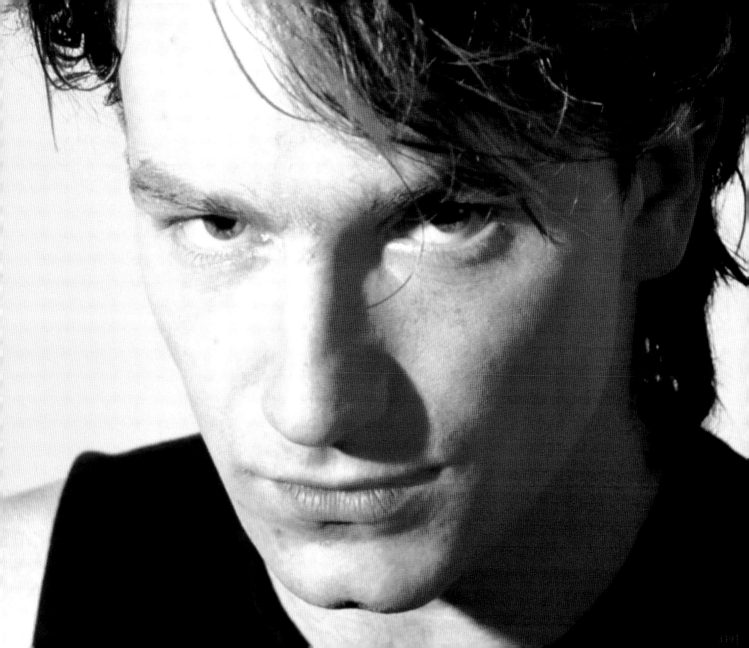

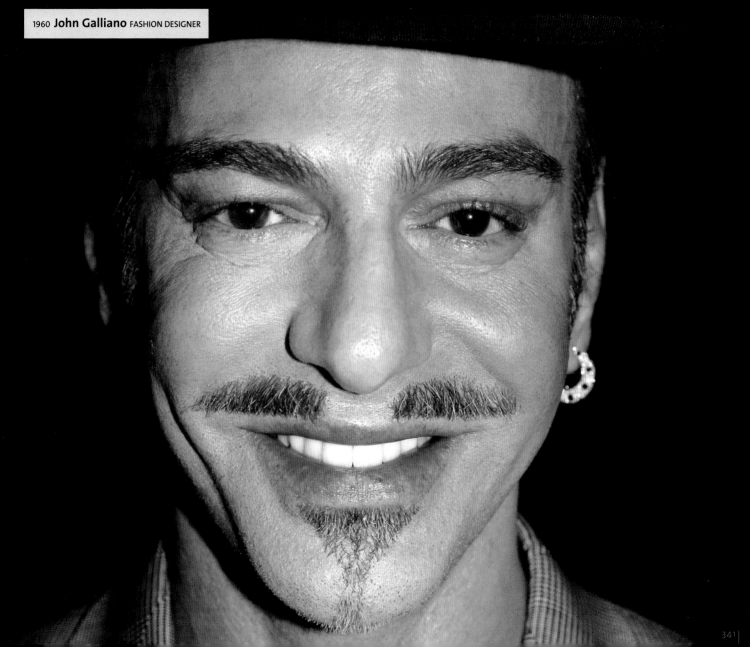

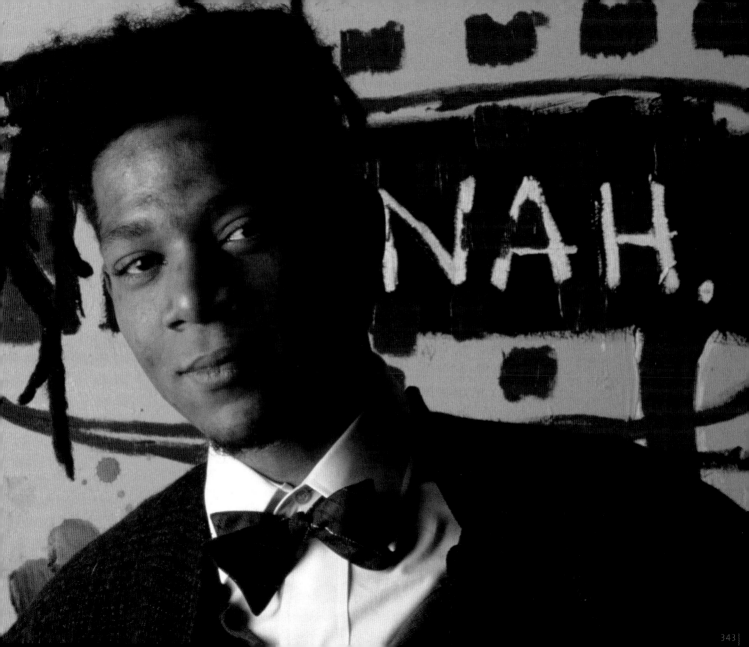

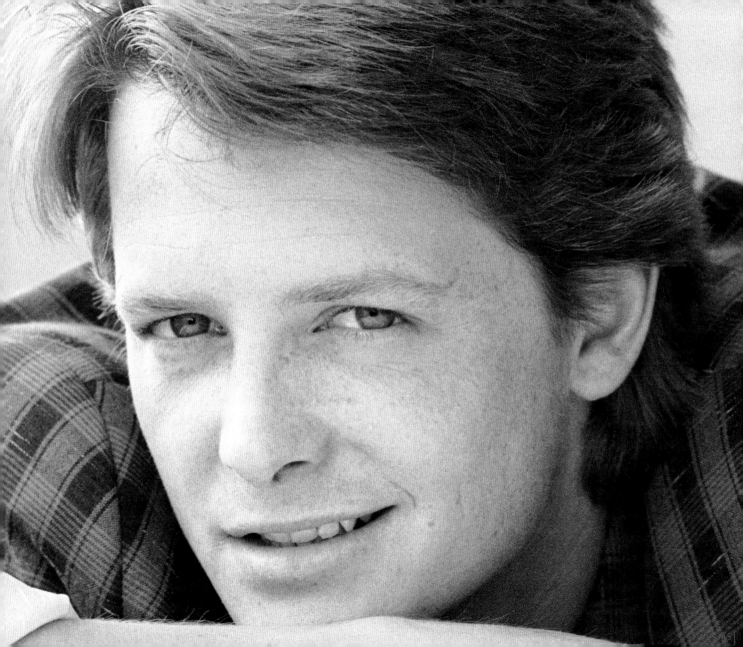

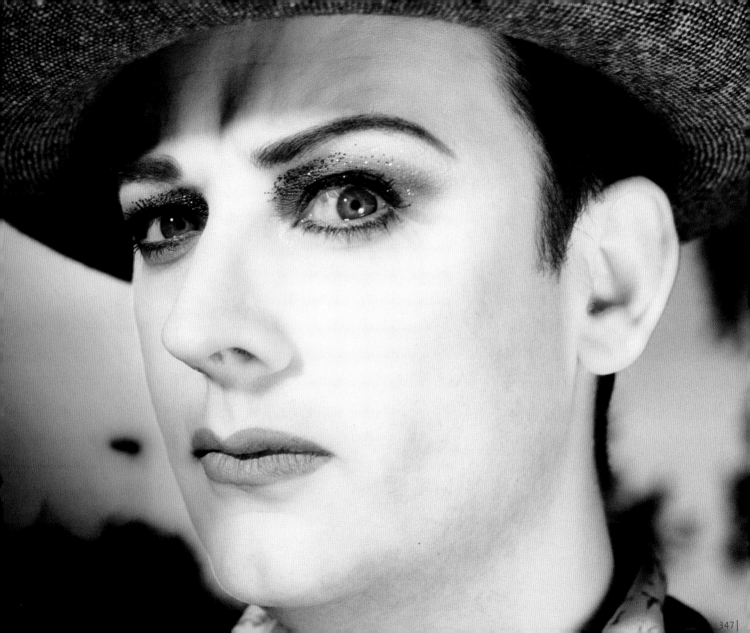

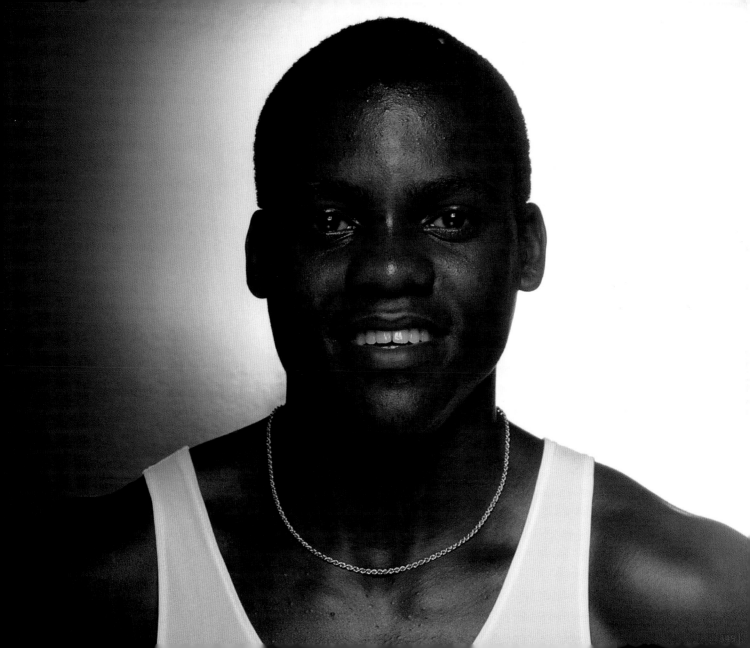

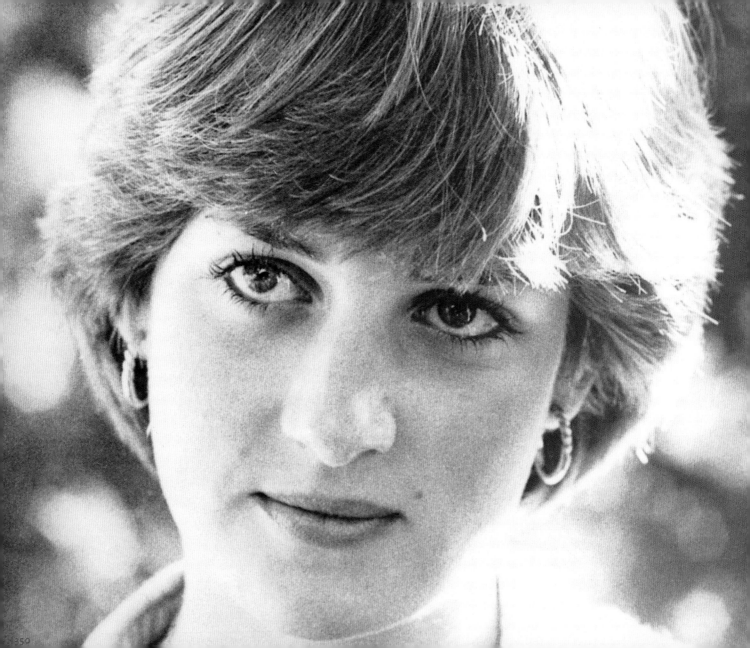

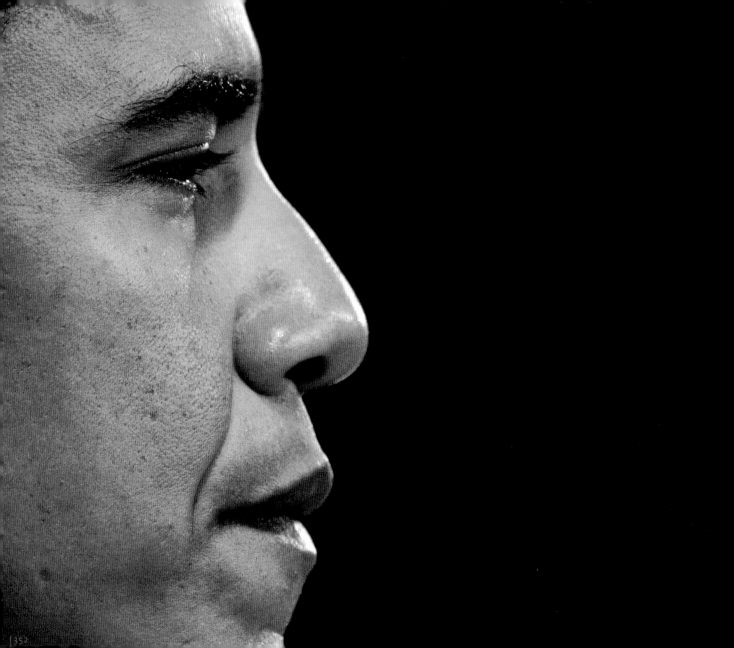

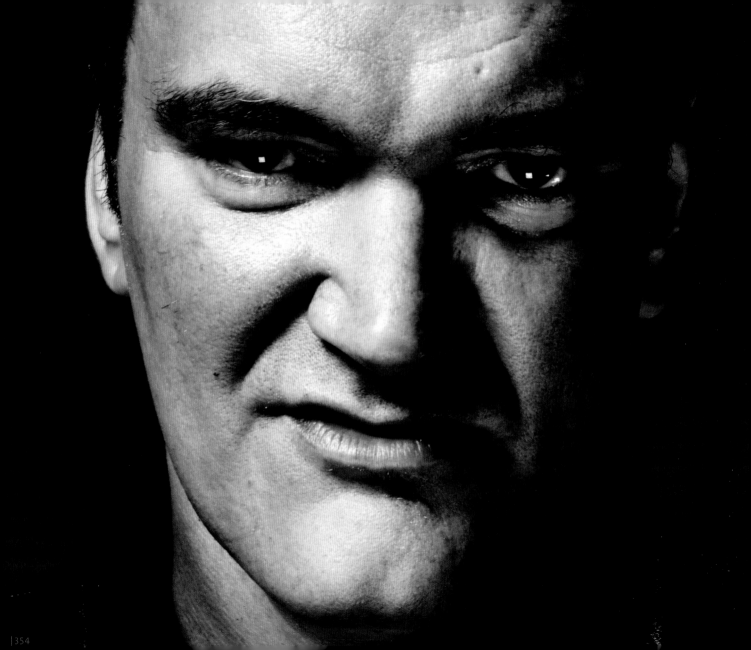

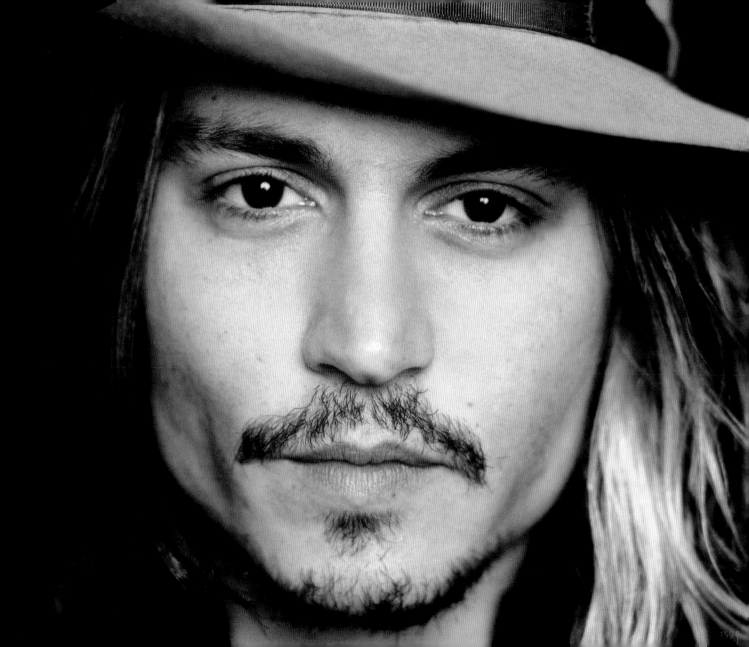

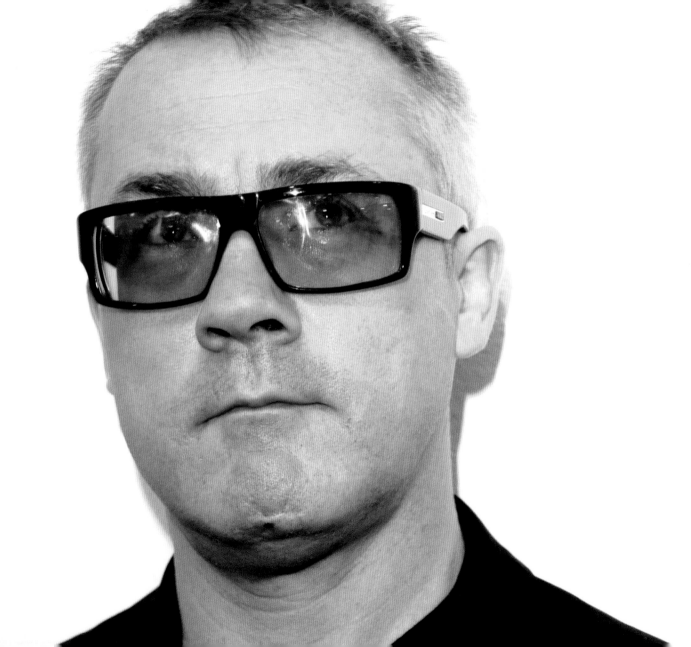

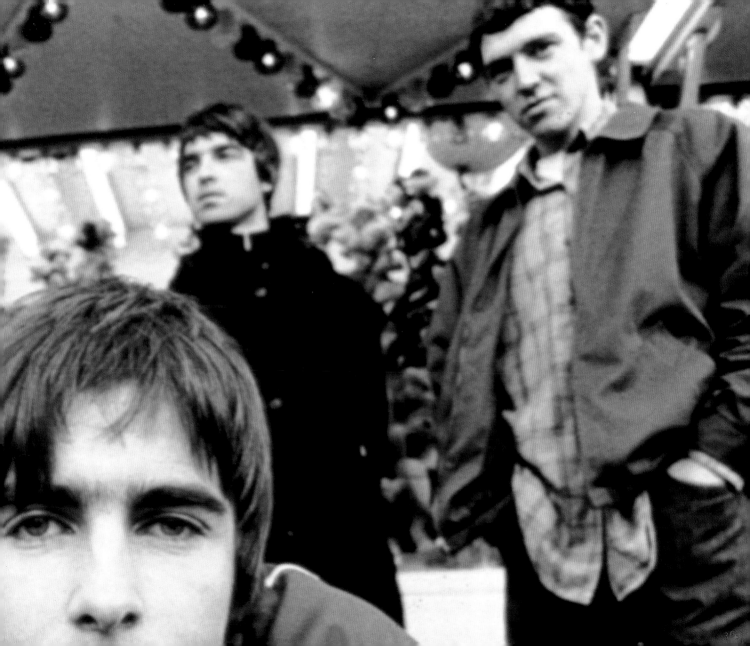

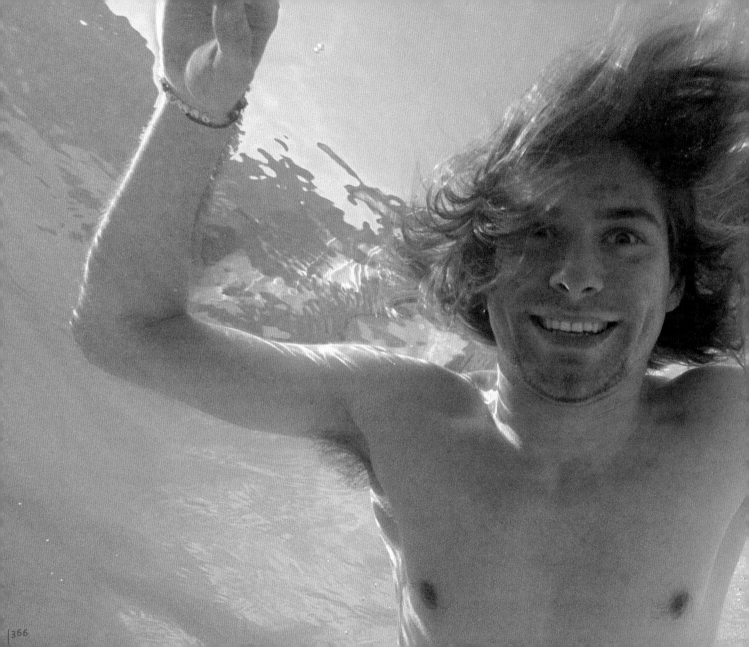

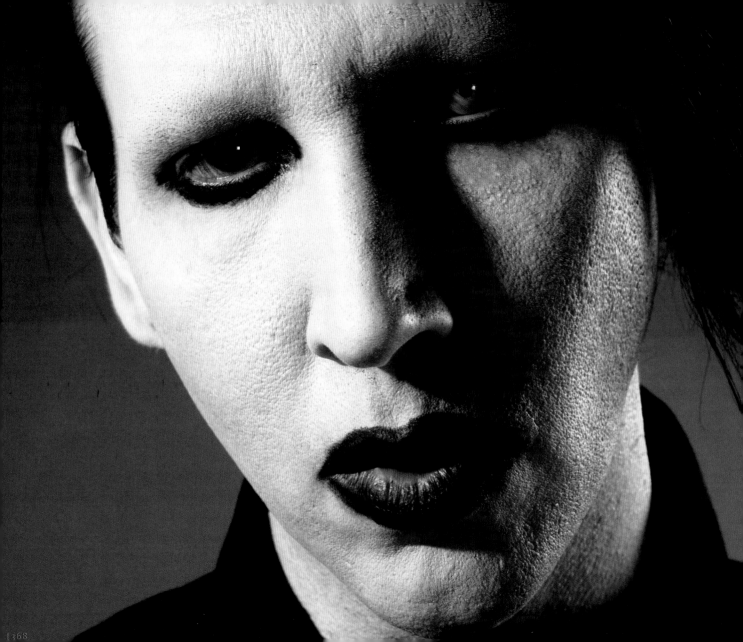

371

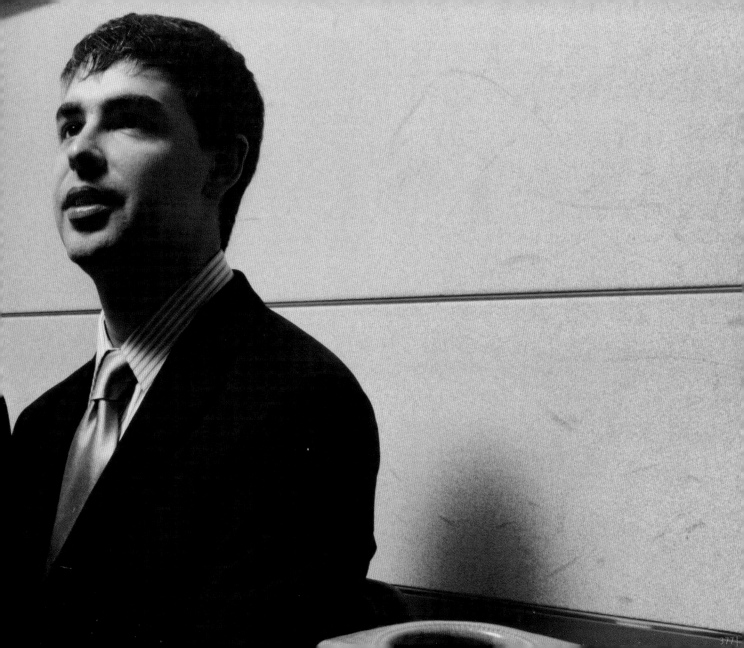

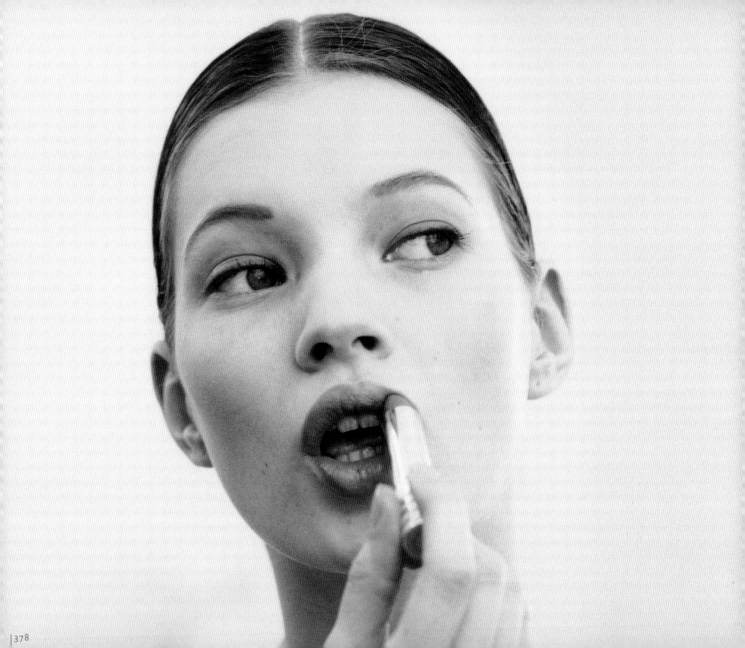

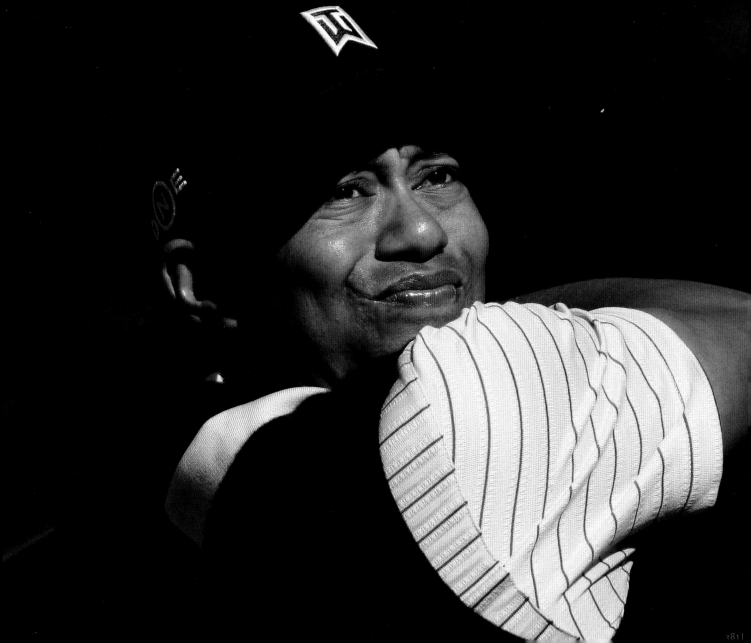

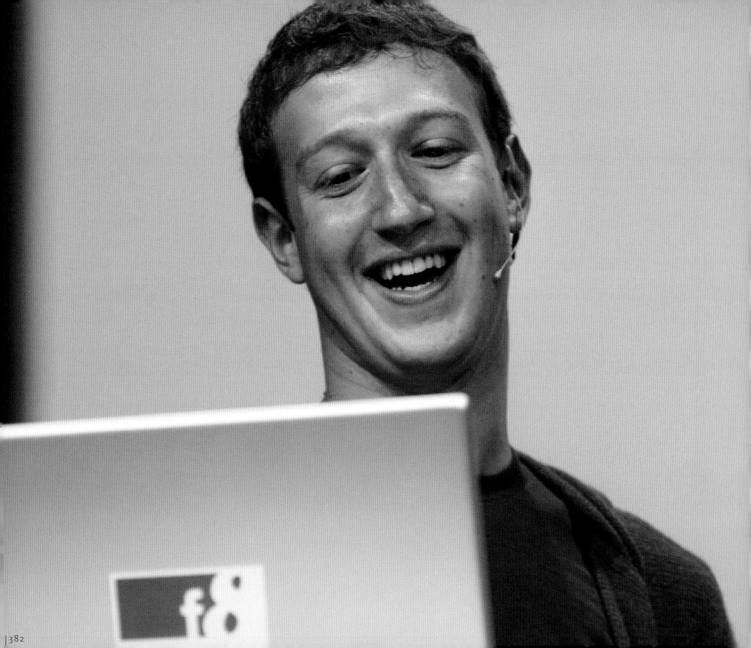